GEAR

IMAGES
of America

PITTSBURG COUNTY

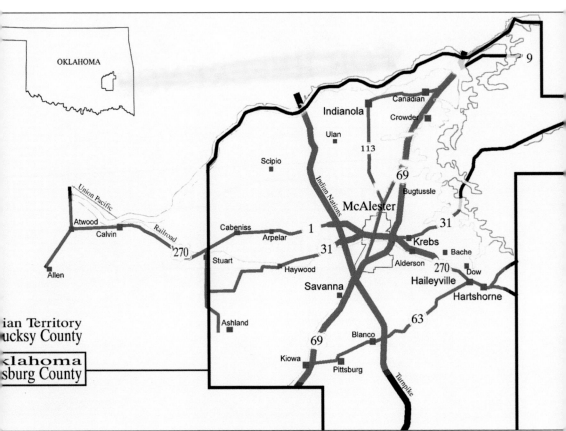

OKLAHOMA

Indianola
Canadian
Crowder
Ulan
113
Scipio
Union Pacific
Railroad
69
Bugtussle
Atwood
McAlester
Calvin
Cabeniss
1
31
Arpelar
270
31
Krebs
Stuart
Haywood
Bache
Allen
Savanna
Alderson
270
Dow
Haileyville
Hartshorne
ian Territory
ucksy County
Ashland
63
Blanco
69
klahoma
sburg County
Kiowa
Pittsburg
Turnpike
9

PITTSBURG COUNTY, OKLAHOMA. Shown with its predecessor, Tobucksy County, Indian Territory, Pittsburg County is located in the southeast quarter of Oklahoma. The county was formed in 1907 at statehood. The Tobucksy County boundary is an overlay of an early map by Oklahoma historian Muriel H. Wright on a prestatehood United States topological map, using natural watercourses and geographic boundaries as they followed Wright's depiction.

On the cover: CHRISTMAS TIME FIRE ENGINE SANTA. Posing in front of the original city hall building and fire department, this group of unidentified McAlester firemen makes preparations for the Christmas season, displaying the collection of toys, food items, and furnishings. The moderate climate of the region regularly allows outdoor activities without the need for heavy outerwear, although the area is not immune to winter weather. (Courtesy of Steve DeFrange.)

IMAGES
of America

PITTSBURG COUNTY

Larry J. Hoefling

ARCADIA
PUBLISHING

Published by Arcadia Publishing
Charleston, South Carolina

Printed in the United States of America

Library of Congress Catalog Card Number: 2007939000

For all general information contact Arcadia Publishing at:
Telephone 843-853-2070
Fax 843-853-0044
E-mail sales@arcadiapublishing.com
For customer service and orders:
Toll-Free 1-888-313-2665

Visit us on the Internet at www.arcadiapublishing.com

*To Fabiola for the unconditional support,
and Martha Lee for the unwavering encouragement.*

CONTENTS

ACKNOWLEDGMENTS

Any history-related work owes a debt of gratitude to those who made the effort to record the original events, or in many cases, provided an understanding based on firsthand knowledge of disparate images and events. Pittsburg County is fortunate to have several entities that are dedicated to the preservation of area history, and this book would have been impossible to create without their collections and expertise. The Pittsburg County Genealogical and Historical Society has long been a staunch defender of the Pittsburg County history, and its continued efforts will insure that the public will have access to both facts and artifacts. In addition, the Krebs Heritage Museum, established in 1996, principally features the Italian origins and life in that community. The groups serve the public well as collecting points and repositories of the colorful and distinct history of Pittsburg County and may be contacted and supported through their respective internet Web sites.

Thanks to Ann Marie Lonsdale at Arcadia Publishing, who first took up the cause on behalf of this project, and to my editor, Ted Gerstle, an especially emphatic note of appreciation for the lengthy telephone conversations and kind words of timely encouragement.

The collective of Pittsburg County historical writings has greatly facilitated the research, and among the efforts that must be highlighted are those of historian Clyde Wooldridge, author of numerous books and articles on McAlester and its vicinity, and especially Thurman Shuller, M.D., a noted authority on Pittsburg County, its mining history, and the influence of William Busby, whose Busby Theater has been the subject of numerous articles published by Shuller. Thanks also to Michael Dean of the Oklahoma Historical Society for his offer of assistance regarding images and articles.

Images and input came from several persons, including Kathy Williams, Martha Hoefling, Lucienda Denson, Richard Moody (Moody's Collectibles), Elizabeth Haskett, Ron Mantegne, Joe Prichard (Pete's Place Restaurant), Howard Drucker (Old Tyme Collectibles), Lesley Brooks, and Lisa Smith (Choctaw Nation of Oklahoma).

Finally, to Steve DeFrange, of the Krebs Heritage Museum, a heartfelt thanks for the cooperation, hard work, advice, and images, without which this work would have gone wanting.

INTRODUCTION

North of the thick pine and oak forests of the Ouachitas, in the foothills beyond the Kiamichi and the Winding Stair Mountains, two trails crossed in the rolling valley nestled between the Shawnee Hills and the Sans Bois Mountains. From that crossroads, it was a two-day march to Fort Gibson, even with the lightest of burdens. To Fort Smith, at the eastern edge of the Indian Territory, the distance was even greater. The Treaty of Dancing Rabbit Creek, signed in 1830, promised that rolling valley to the Choctaws, part of the tract that would become the new home of a relocated nation.

The woods rivaled the rugged timberland of the Choctaw homeland, a "vast, trackless wilderness of trees, a dead solemnity" that extended from the rolling foothills into the dense forest of the Ouachita range. English botanist Thomas Nuttall wrote in 1819 of his expedition up the Red River, describing a range similar to the Appalachians consisting of clay and sandstone that he dubbed the Massern Range.

The bottomland held fertile soil, although it was prone to flooding, and the foothills held a thin soil not conducive to farming. Beyond the foothills of the Ouachitas stood forests of cottonwood, elm, walnut, pecan, and hickory trees, and the more mountainous areas to the southeast featured a wide variety of oaks. Along the creeks and rivers were canebrakes that grew in such profusion that "a bird would find it difficult to fly through them."

Disagreements existed between the chiefs of the Choctaws regarding removal from Mississippi, but the continued emigration of nontribal members onto their lands resulted in conflicts, and there was no support by Pres. Andrew Jackson for the idea of coexistence. At the time, few believed the United States would ever extend beyond the Mississippi River, and most believed that vast land could provide a perpetual homeland for the Choctaws, free of the depredations of unsympathetic whites.

Mushulatubbee, one of the leading chiefs of the Eastern Choctaws in Mississippi, was a signer of the Dancing Rabbit treaty that exchanged his people's holdings in that state for land west of the Mississippi River. The tract of land, further reduced by subsequent treaties, eventually comprised the southeastern quadrant of land in what became eastern Oklahoma, bordered by the Red River at the south and the Arkansas and Canadian Rivers at the northern boundary. Along its eastern edge was the Arkansas border, and to the west, the boundary was a line drawn as part of a treaty of separation with the Chickasaw Nation, along the 98th meridian west of present-day Durant.

The valley of the two roads, located in the northwest corner of the Choctaw Nation, was part of the political district named for Chief Mushulatubbee, and from its earliest days it was noted for mineral deposits so abundant they could be dug up by hand and sold by the basket. In

November 1855, the separation of the Chickasaw Nation forced the formation of a fifth county in the Mushulatubbee District, named for the rich reserves of coal, which—in the language of the people living there—was *tobaksi* or *Tobucksy*.

Tobucksy County, at the northern edge of the Choctaw Nation, would validate the description of its translated name through the large-scale mining and shipping of coal from the valley, long before Oklahoma statehood brought about a reconfiguring of lines and a renaming of the county.

Early marriages allowed for settlement rights within the Indian Territory, and among those settlers were men who recognized the value of the minerals to be found throughout the valley of the crossroads. In an age where coal was king, the discovery amounted to the basis for a prosperous economy, and the influx of emigrants from economically struggling European nations provided much of the labor force required to build, market, and deliver the product upon which so many area communities were founded.

In 1907, when the lands of the nations that comprised Indian Territory were combined with Oklahoma Territory and entered the United States as the state of Oklahoma, the various political boundaries were redrawn. Perhaps with great expectations that the area's supply might rival those in the northeast, the redrawn county was renamed Pittsburg, after the city holding "the most valuable individual mineral deposit in the U.S.," Pittsburgh, Pennsylvania. The county seat was set at McAlester, a thriving community and transportation center, and the twin communities of McAlester and South McAlester were already combined under the single name.

The new boundary encompassed some 1,306 square miles in the rolling foothills of the Kiamichi Mountains, much of which was amply stocked with readily accessible coal reserves. In that period before statehood, when the burning of coal constituted one of the primary energy sources for the world, the production and mining became a source of revenue for early residents and a promise of employment for newly arriving groups of immigrants.

When the railroad line was completed in a north-south passage through Indian Territory, it allowed for the easy shipping of the great amounts of coal brought from the ground. Recognizing the opportunities, several companies were organized by the railroads for the explicit purpose of mining and shipping coal from then Tobucksy County.

In addition, the railway provided a link to the rest of the world that brought to the unpaved communities goods and culture generally reserved for more metropolitan areas. At the beginning of the 20th century, before Oklahoma had been named, McAlester held one of the largest populations in the pre-statehood Twin Territories, and the diversity and unrivaled wealth brought a cosmopolitan nature little seen in the western United States at the time. From touring national theater companies, to New York's Metropolitan Opera, to fraternal and social organizations, Pittsburg County was able to play host thanks to visionary men such as James Jackson McAlester, William P. Busby, Daniel M. Hailey, Edwin Chadick, J. G. Puterbaugh, George W. Choate, Edmond Krebs, William B. Pitchlynn, Aaron Arpelar, Joshua and William Pusley, and others—entrepreneurs of the Choctaw Nation either by marriage, birth, or association, whose personal ideas, efforts, and fortunes provided the infrastructure and amenities for the growing communities.

From the outset, McAlester and Pittsburg County have served as homes to national organizations and state and national political leaders, as well as notables from the sports and entertainment fields, with names like Carl Albert, speaker of the United States House of Representatives; Warren Spahn, a member of the Major League Baseball Hall of Fame; St. Louis Cardinal outfielder Pepper Martin; two-term Oklahoma governor George Nigh; Grammy Award–winning country singer Reba McIntire; and others.

The community takes pride in its heritage, which is featured annually in festivals and as a destination for the many visitors who recognize the value of tradition and the quality of people who call Pittsburg County home.

One

THE CHOCTAW NATION

There were settlements in the area of the crossroads as early as September 28, 1830, when the Dancing Rabbit treaty was signed by the Choctaws. Military travel from Fort Smith passed through on the way to Fort Towson as early as 1824. Robert Bean and Jesse Chisholm blazed the trail for a military road from Fort Gibson to Towson in 1832. As the Mississippi Choctaws arrived after the heartbreaking and physically demanding relocation, settlements quickly sprang up and a post office designation recognized Perryville, just south of present-day McAlester, in 1841.

By 1849, 547 additional Choctaws made the trek from Mississippi to the new Indian Territory. Some 7,000 Choctaws soon followed, settling in the Mushulatubbee District, building homes, planting corn, and otherwise assimilating with the existing residents. The influx of settlers continued despite the occasional hardships, drawn perhaps by the geography, described by early resident Henry Benson as "rough and wild" but also "novel, variegated, and picturesque," with an excellent water supply, moderate temperatures, and good grazing land, where "the fruit trees bloomed in February."

By design or fortune, Perryville, the Perry family's early settlement in the Choctaw Nation, had the distinction of being located nearly exactly where the California Road crossed the Texas Road in a valley of the foothills that would become Pittsburg County. Although the site was rebuilt after being burned during a Civil War skirmish, it did not survive the introduction of the railroads at McAlester, when commerce and community moved north to the rail crossing.

Immediately following the Civil War, the United States government required that the tribes extend full legal membership to their former slaves, and Principal Chief Allen Wright of the Choctaw Nation faced the task of recovery. The nation was mired in public debt, caught in an educational system breakdown, facing problems with the freedmen, and suffering the indignities of thieves and outlaws. Wright acknowledged the effects of the war, saying, "Our people have suffered enough for the last few years . . . now let each one study to restore peace, harmony and good order, which were lost amidst confusion and war."

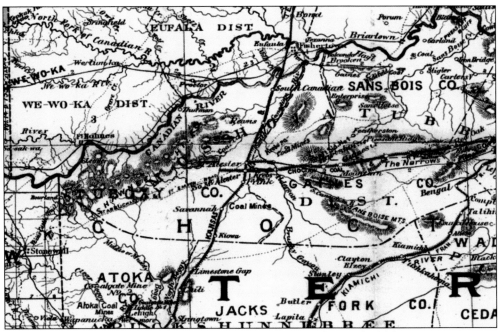

AN 1894 MAP OF MOSHOLATUBBEE DISTRICT. The map of Indian and Oklahoma Territories was compiled in 1894 from records of the United States General Land Office and shows coal mines and the railway crossings at South McAlester, Indian Territory, of the Missouri-Kansas-Texas (MKT) Railroad and the Choctaw Coal and Railway Company, the earliest of the east-west lines completed largely under the direction of Edwin Chadick. (Courtesy of Library of Congress.)

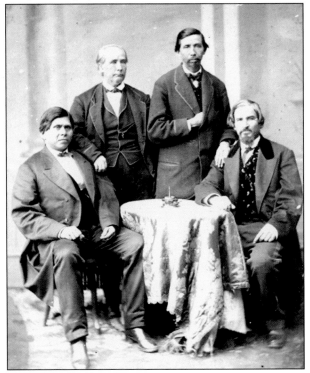

THE 1866 CHOCTAW TREATY DELEGATION. The United States required the signing of a post–Civil War Treaty with the Choctaws containing land concessions and the prohibition of slavery. Representing the Choctaws were (from left to right) Allen Wright, Campbell Leflore, Julis J. P. Folsom, and F. Batiste. Allen Wright served as chief of the Choctaw Nation from 1866 to 1870. (Courtesy of the Oklahoma Historical Society.)

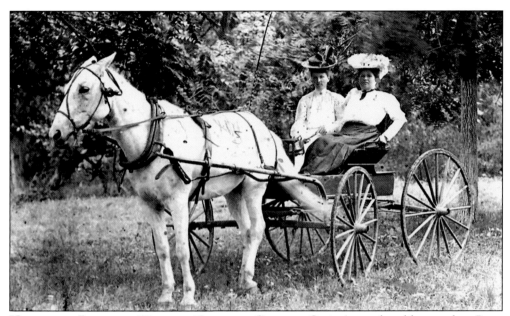

Horse and Buggy in Western Tobucksy County. Ottie Atwood and her mother, Patsy Ann, familiarly called Mattie, settled in western Tobucksy County, which was later incorporated into Hughes County. The Atwood farm was some 28 miles west of J. J. McAlester's general store. Until the railroad line was completed, trips to town were accomplished by horse and buggy. (Courtesy of Howard Drucker, Ole Tyme Antiques.)

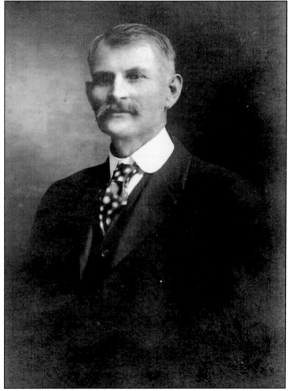

Chester C. Atwood. Born in Texas, Chester C. Atwood left for Indian Territory and obtained settlement rights through marriage to a Choctaw woman named Patsy Ann in 1882. Atwood increased his land holdings by 1900, and his family included son Bennie and daughters Ottie, Arrie, Allie, Lizzie, and Ambrosia. He was an elected commissioner, and the community of Newburg was renamed Atwood in his honor in 1909. (Courtesy of Howard Drucker, Ole Tyme Antiques.)

11

CHOCTAW NATION EXECUTIONER. Lyman Pusley, a member of one of the earliest families to reside in Pittsburg County, carried out the capital punishments when so required. J. J. McAlester is said to have been sentenced to death for continuing to mine where prohibited on Choctaw land but escaped while the executioner searched for other offenders to not squander an execution on a single man. (Courtesy of Steve DeFrange.)

CHOCTAW NATION WHIPPING POST. Lawbreakers commonly faced lashings administered by members of the tribal police force called the Lighthorse. Offenders were tied to a tree or post and subjected to a number of lashes across the back. Despite the occasional high-profile case, most criminal work involved suppressing the manufacture and sale of Choctaw beer, a brew that originated in the Indian Territory. (Courtesy of the Choctaw Nation.)

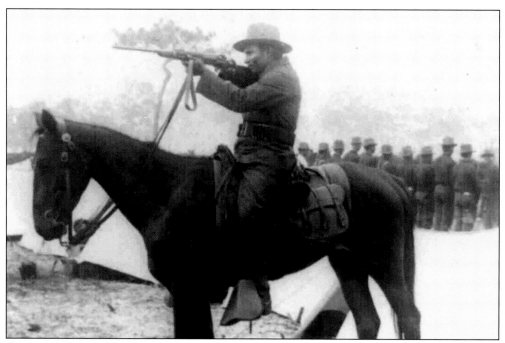

CHOCTAW ROUGH RIDER IN THE SPANISH-AMERICAN WAR. Bankston Johnson lived south of McAlester but enlisted at Muskogee on May 14, 1898, for the special regiment of mounted cavalry called the Rough Riders, the group associated with Pres. Theodore Roosevelt. The directive to form the unit called for "raising a regiment of cowboys as mounted riflemen." (Courtesy of Library of Congress.)

ARMY PAY AND MUSTER ROLL. Company M, First United States Cavalry Volunteers assembled at San Antonio, Texas, and arrived in Cuba on June 22, 1898. Bankston Johnson, a "full blooded Choctaw Indian," was part of the June 24, 1898, Battle of Las Guasimas and the Battle of San Juan Hill on July 1, 1898. He served through September 5, 1898. (Courtesy National Archives and Records Administration.)

13

FIRST TOBUCKSY COUNTY COURTHOUSE. In 1876, Daniel M. Hailey built a home for a relative, enabling a move to town and the attending of school. Later it was given to the Choctaw Nation and moved to North McAlester. Among the early Tobucksy County judges were George W. Choate, Edmond Krebs, Albert Carney, William B. Pitchlynn, G. M. Bond, Aaron Arpelar, and Solomon Mackay. (Courtesy of Steve DeFrange.)

OLDEST SURVIVING BUILDING IN PITTSBURG COUNTY. After statehood, the former Choctaw Nation Courthouse was used by the Oyohoma Club, a Choctaw Nation ladies organization. In the latter part of the 20th century, it was turned over to the City of McAlester and moved to a location south of the original J. J. McAlester residence. (Courtesy of Steve DeFrange.)

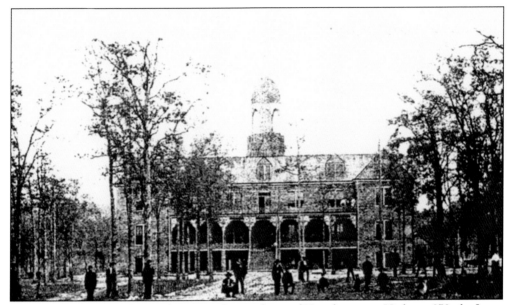

BOYS' DORMITORY AT JONES ACADEMY. Located east of Hartshorne on Highway 270, the Jones Academy for Boys was named for Wilson N. Jones, the principal chief of the Choctaw Nation from 1890 to 1894. The school was established in 1891 on 540 acres of Choctaw land and has operated under the auspices of the Choctaw Nation and the Bureau of Indian Affairs. (Courtesy of the Choctaw Nation.)

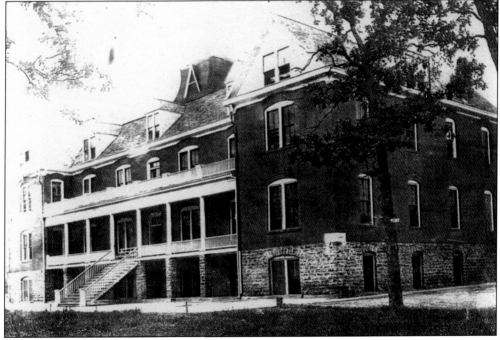

ADMINISTRATION BUILDING AT JONES ACADEMY, 1920. The Choctaw Nation tribal school was initially established as an all-boys academy, but in 1955, the Wheelock School was closed, and students of that institution transferred to Jones Academy. The school came under the total control of the Choctaw Nation in 1988. (Courtesy of the Choctaw Nation.)

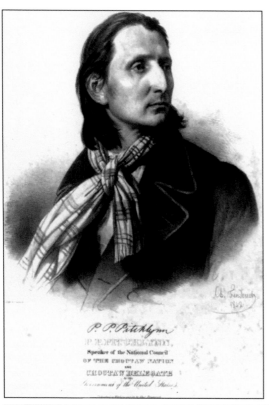

PRINCIPAL CHIEF PETER PITCHLYNN. In the language of the Choctaws, his name was Hat-choo-tuck-nee, the Snapping Turtle, but he was widely known among whites as Peter Perkins Pitchlynn, the son of Col. John Pitchlynn and Sophia Folsom, a Choctaw. This engraving was made in 1842 after Pitchlynn aided in selecting land for the removal of the Choctaw Nation from Mississippi. (Courtesy of the Library of Congress.)

KITCHEN FACILITY AT JONES ACADEMY. The Choctaw Nation maintained boarding schools as early as 1860, and Jones Academy featured academic training in addition to practical industrial training in farming, dairying, engineering, and blacksmithing. Those enrolled in the tribal-controlled residential facility now attend Hartshorne public schools in Pittsburg County. (Courtesy of the Choctaw Nation.)

Two

THE EARLY SETTLERS

Hardy Perry was a trader among the Mississippi Choctaws, and his sons Isaac and Lewis Perry signed the Dancing Rabbit treaty in 1830. Isaac moved to Indian Territory along with brothers James, Joseph, and Edmund Perry, establishing an early settlement called Perryville, south of present-day McAlester. Several prominent families made their start there, including Sam Baumgarner, the Reverend James Y. Brice, William Chunn, Tom Ryan, William W. Choate, Pleasant Tackett, John Dawson, Henry Norman, and Dr. Daniel M. Hailey.

In addition to the Choctaws, there was a substantial population of African American residents, dating from the years before emancipation. To appease intruders in the territory, the tribes had adopted Anglo-American traditions of farming, education, and slave holding, practices that prompted the term Five Civilized Tribes.

Joshua Pusley of the Choctaw Nation leased a coal mine in 1872, and in 1875, William Pusley, another Choctaw, entered a lease near present-day Krebs. Another early leaseholder was James Jackson McAlester, an entrepreneur who was among those recognizing the commercial potential of the abundant coal deposits.

McAlester, an Arkansas Civil War veteran, left Fort Smith to work with Aaron Harlan and C. C. Rooks, and later James E. Reynolds and J. T. Hannaford, who operated trading posts in Indian Territory. McAlester was able to convince the partners to establish another post at a site called Bucklucksy. The same day he arrived with goods and materials in late 1869, a time when hard currency was scarce, McAlester is said to have sold out his merchandise, while the lumber to construct his trading post building was still on the ground.

J. J. McAlester later bought out Reynolds's share of the trading post and journeyed with a sample of coal to Parsons, Kansas, in hopes of persuading railroad officials to locate the rail line near his store at Bucklucksy. The location of the trading post on the Texas Road weighed in its favor, given that the Katy Railroad construction roughly followed the Shawnee Trail-Texas Road route to the Red River. The line reached Bucklucksy in 1872, and Katy officials named the railway stop McAlester.

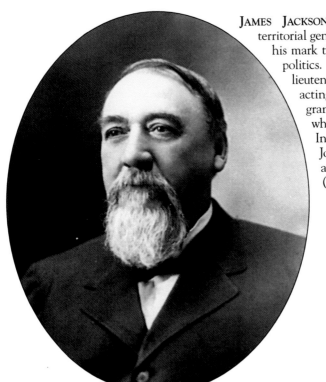

JAMES JACKSON MCALESTER. Rising from a territorial general store clerk, J. J.McAlester left his mark through mining, investments, and politics. He served as federal marshal and lieutenant governor of Oklahoma, and as acting governor on April 24, 1915, he granted a pardon to Frank Sibenaler, who had been erroneously convicted. In the movie *True Grit*, actor John Wayne's character stopped at the McAlester's general store. (Courtesy of Steve DeFrange.)

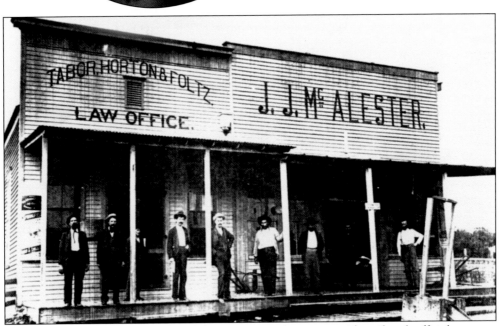

SOUTH STORE LOCATION. After failing to come to terms with railroad officials over a right-of-way, J. J. McAlester lamented to a newspaperman that he spent thousands of dollars obtaining land titles in South McAlester, the community where the two railroad lines crossed—several miles south of his original store. The two separate towns were combined into a single municipality before Oklahoma statehood in 1907. (Courtesy of Steve DeFrange.)

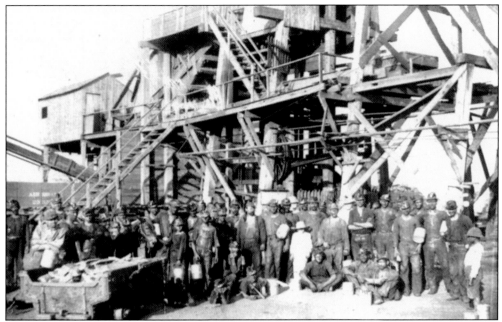

COAL MINERS AT KREBS NO. 5. A joint venture of J. J. McAlester and Daniel Hailey, the Osage Coal and Mining Company, the first shaft at Krebs came to be called the Old No. 5 Krebs Mine. Its production required transportation changes, and the east-west railway development is largely credited to Edwin D. Chadick, a Minneapolis newspaperman who found support for the establishment of a line in 1888. (Courtesy of Steve DeFrange.)

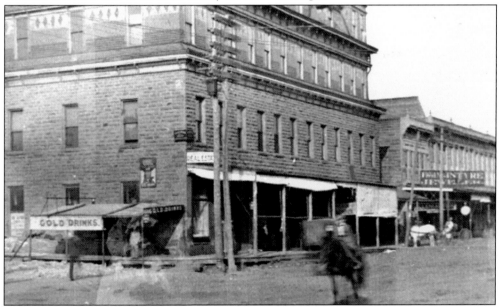

RARE VIEW OF THE KALI-INLA BUILDING. Edwin D. Chadick located the headquarters for his railway company at the intersection of his Choctaw Coal railroad line and the Katy, but despite his grand intentions the company met with financial difficulties, and work on the building was ordered halted more than once. Few images remain of the once impressive structure that originally housed the United States federal court. (Courtesy of Steve DeFrange.)

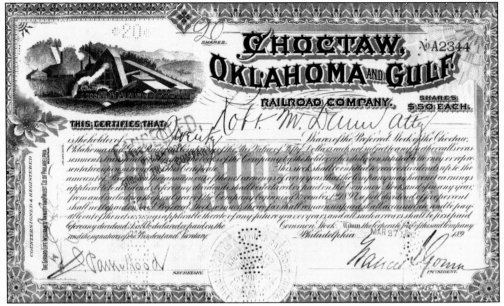

EARLY DAY RAILWAY STOCK. When the Choctaw Coal and Railway Company met with financial troubles and entered receivership, Francis Gowen and Edwin D. Chadick were named as coreceivers. In 1894, Francis Gowen was named president of the reorganized company, to be known as the Choctaw, Oklahoma and Gulf Railroad, and it is his signature on this stock certificate issued to attorney Robert M. Dunn. (Courtesy of McHuston Booksellers.)

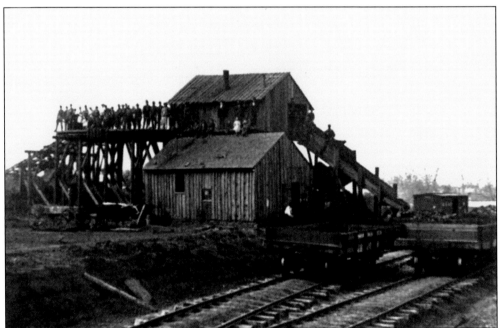

OSAGE COAL MINE NO. 9. Coal was the driving force in the local economy and was responsible for the relocation of a great many immigrant families to Tobucksy/Pittsburg County. The product of the many mines was advertised and shipped nationally by rail all over the United States under various trade names. (Courtesy of Steve DeFrange.)

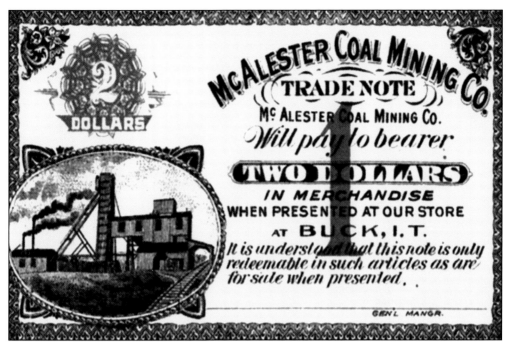

COMPANY STORE TRADE NOTE. For more than a decade, J. J. McAlester issued his own currency and tokens, in denominations from 5¢ to $1, and redeemable at his general store, a practice followed by several local merchandisers. At statehood, McAlester held office as a member of the state Corporation Commission, and in 1911, he took office as lieutenant governor. He died on September 22, 1922. (Courtesy of McHuston Booksellers.)

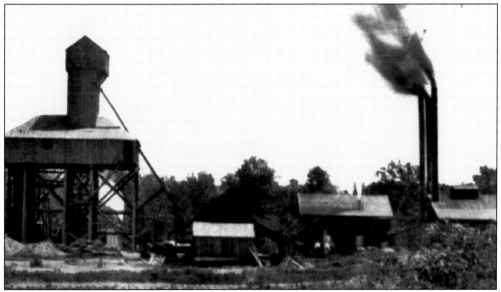

COAL MINE AT BUCK, INDIAN TERRITORY. Among those locales that disappeared from the maps, Buck featured mines and a company store owned by J. J. McAlester. Author Alice Lowe Bullock, known for her writing and photography of the Santa Fe, New Mexico, area, was born at Buck, Indian Territory, in 1904. Her father, Richard Lowe, worked as a fireman at the Buck mine. (Courtesy of Steve DeFrange.)

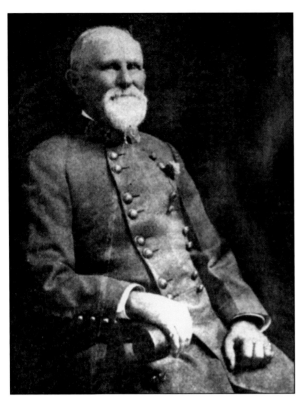

DANIEL M. HAILEY. The son of an Irishman who immigrated to Louisiana, Daniel Hailey studied at Tulane and entered the Louisiana Infantry of the Army of the Confederacy in 1861, assigned to Hay's Brigade. He was wounded and taken prisoner but returned to duty in 1865 as part of a prisoner exchange. This picture of Hailey in his uniform was taken in 1912. (Courtesy of Steve DeFrange.)

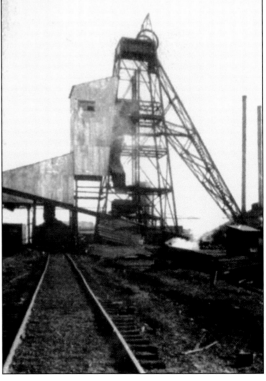

NO. 7 HAILEY-OLA MINE. Daniel Hailey practiced medicine and operated a store at Perryville before moving to present-day McAlester. He was named the first postmaster at Savanna and Brooken on January 26, 1880, and later entered the mining industry, operating under the trade name of Hailey-Ola. The town of Haileyville was named for him, but ironically, he never had a residence there. (Courtesy of Steve DeFrange.)

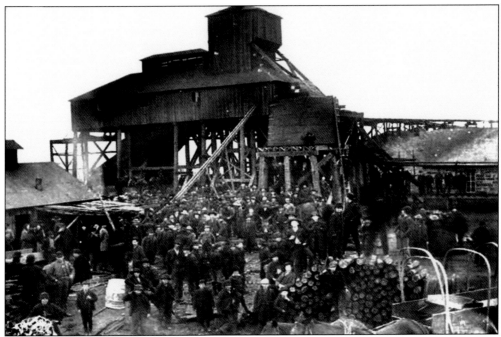

NO. 11 OSAGE COAL AND MINING COMPANY. This mine was the site of the horrific explosion in 1892, resulting in the worst mining accident in territory history. Over 100 men and boys—some as young as 12—died in the blast, and many were buried in a mass grave in North McAlester. The disaster led to the establishment of several hospitals in the area. (Courtesy of Steve DeFrange.)

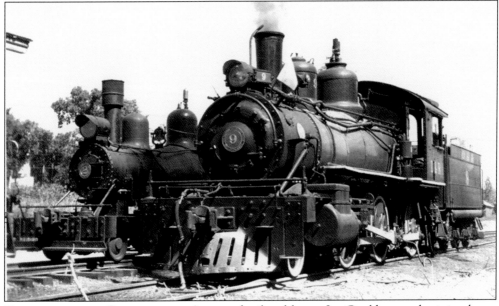

DARDANELLE AND RUSSELLVILLE. Agents of railroad baron Jay Gould entered mining leases at Savanna at the urging of William Pusley and Daniel Hailey, who discovered coal there. The town's name, Savanna, is said to have been for the personal railcar of Katy general manager Robert S. Stevens. These steamers are typical of the 1900 railroad engines that served the Pittsburg County coal mines. (Courtesy of McHuston Booksellers.)

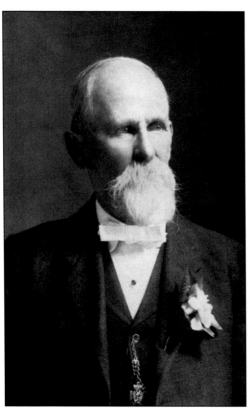

DANIEL MORRIS HAILEY. In addition to his physician duties, Hailey edited the *Star Vindicator* newspaper with Granville McPherson as printer and business manager. In 1876, McPherson left for Texas and Hailey relocated to present-day Savanna to operate mines with William Pusley. Hailey acquired the Osage Trading Company and in 1886 merged his company with that of J. J. McAlester, forming J. J. McAlester and Company. (Courtesy of McHuston Booksellers.)

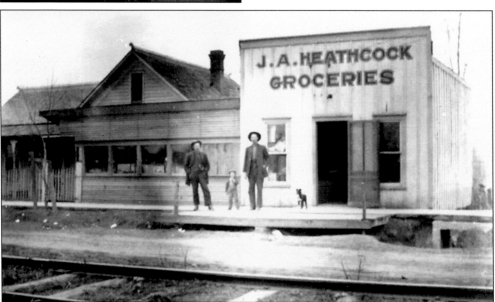

J. A. HEATHCOCK GROCERY AT KREBS. The rail line from McAlester allowed commerce to begin at Hartshorne and beyond, although streets were dirt with pedestrian boardwalks. Born in Alabama in 1867, J. A. Heathcock brought his family to Indian Territory before statehood and served as justice of the peace. He lived in Krebs with wife, Nellie M., and children Jessie, Callie M., Turner, and Catherine. (Courtesy of Steve DeFrange.)

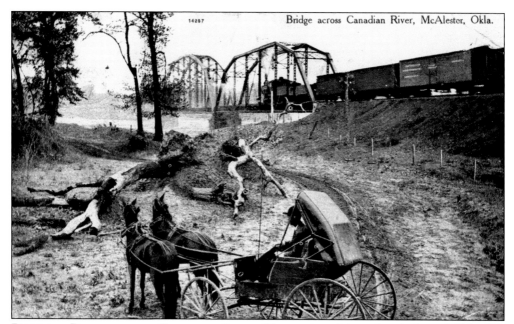

RAILROAD BRIDGE ON THE CANADIAN RIVER. The coming of the railroads through Tobucksy County helped to bring an end to the day of the horse and buggy, although complaints about the unpaved streets continued into the days of statehood. The Canadian River constitutes the northern boundary of the county and separated the lands of the Choctaw from the Cherokee Nation to the north. (Courtesy of McHuston Booksellers.)

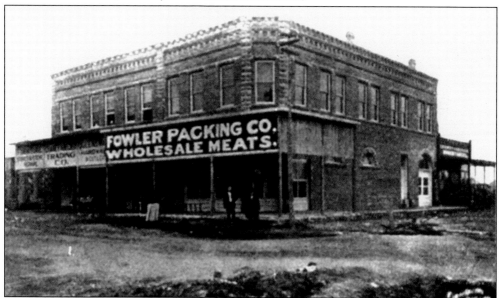

CHANEY, BECKER, AND FOWLER. Sharing a building with the Fowler Packing Company was Chaney and Becker Trading Company. Pennsylvania native George Chaney entered Indian Territory and set up shop around 1885. Leo Becker was an 1870 emigrant from Germany who entered the furniture trade. The Chaney and Becker Trading Company offered embalming among its services, and the Chaney Funeral Home later became a McAlester institution. (Courtesy of Steve DeFrange.)

EARLY DAY MANTEGNA FAMILY HOME. Like the population itself, housing structures filled a spectrum during the growth years before statehood. Examples exist of some of the finest period homes of Indian Territory, as well as surviving structures that typify the homes of the workingman and his family. Houses were generally wood frame with a native stone foundation and were strictly no-frills habitation. (Courtesy of Ron Mantegna.)

EARLY PHOTOGRAPH OF PETE'S PLACE RESTAURANT. Behind all the trees stands the original Pete's Place Restaurant, serving family-recipe Italian cooking for over 80 years. The restaurant remains in the family, although the unpaved roads are gone, along with the rural farmhouse appearance. The location is unchanged, but time has changed the access, including rerouting of the east-west highway through Krebs. (Courtesy of Joe Prichard.)

Three

IMMIGRANTS AND THE BOOM YEARS

An economic downturn in Italy beginning in 1870 brought a wave of immigrants searching for employment, and the rich coal deposits and active mining operations offered opportunities for those willing to enter the coal mines.

The lack of a modernized agricultural system in Italy combined with a series of epidemics brought many Italians to the point of starvation, and many saw no alternative but emigration. Between 1876 and 1924, more than 4.5 million Italians left for the United States from a total Italian population of only 14 million. During that time, the majority of those arriving were young men in their teens and 20s who intended to work, save money, and eventually return to Italy. Upwards of 75 percent of those who initially immigrated remained as permanent U.S. residents.

Tobucksy County coal mines offered immediate employment for the incoming Italians, and the geography presented opportunities for the immigrants to establish their own communities. A government study in 1911 indicated, "many in the coal regions who have been in this country from fifteen to twenty years are scarcely able to speak English. They live in colonies, have very little association with natives, and show little interest outside of their own immediate neighborhood."

The continued success of the Krebs and other area mines brought a prosperity that allowed continued hiring, and the influx of the various ethnic groups into Tobucksy County served to make it the most diverse part of the territories. The area became a bastion of organized labor in later years.

By the year 1900, Tobucksy County was a cosmopolitan mixture of locals and immigrants, with first-generation residents representing nearly every state in the United States and several continents. Not surprisingly, the majority of the Tobucksy County residents came from the United States and its territories, but significant minority groups existed.

From the American continent, first-generation residents from every state except Delaware appeared in United States census records for Tobucksy County, in addition to residents listing Canada and Mexico as their place of birth. European countries listed were Italy, Germany, Austria, Ireland, Russia, England, France, Switzerland, Sweden, Scotland, and Wales.

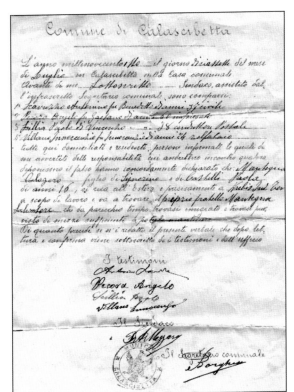

EMIGRATION PAPERS OF CARL MANTEGNA. The official 1910 paperwork from Italy featured handwritten text along with the official signatures and the seal of the City of Calascibetta. Carl Mantegna's destination is as listed Krebis, Indian Territory, and later that year 17-year-old Carl was living with his brother Salvatore, who had immigrated in 1905. Both were employed in the Krebs coal mines. (Courtesy of Ron Mantegna.)

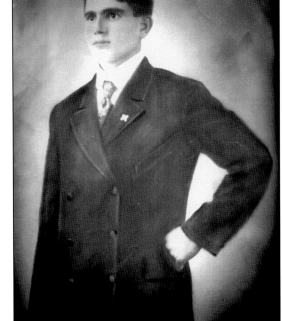

PORTRAIT OF SALVATORE MANTEGNA. A young man at the time of his immigration, the dapper Salvatore posed for this picture in 1905, about the time of his arrival in the United States, and was living on McAlester Road in Krebs by 1910, where he was working as a coal miner. (Courtesy of Ron Mantegna.)

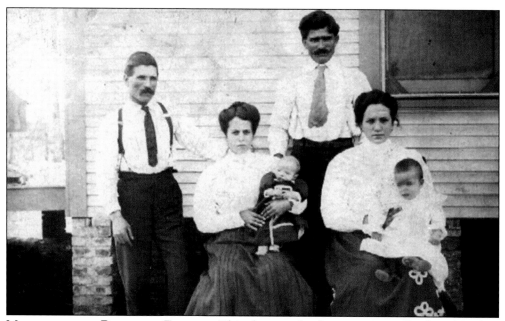

MANTEGNA AND RANDAZZO FAMILIES. This photograph of two young couples dates from late 1910, when they were next-door neighbors on McAlester Road in Krebs. Sam and Angelina Mantegna had a son Henry, and Joe and Carmella Randazzo had a daughter Ellen. Both children were born in 1910. Joe later moved to a farm on Peaceable Valley Road in Alderson, leaving the house to Mario and Mary Randazzo. (Courtesy of Ron Mantegna.)

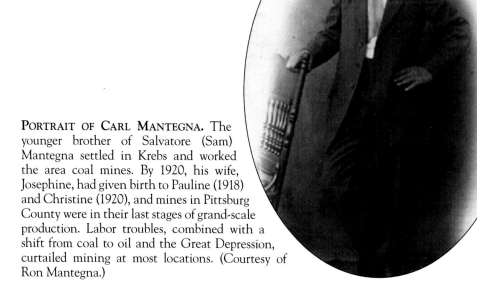

PORTRAIT OF CARL MANTEGNA. The younger brother of Salvatore (Sam) Mantegna settled in Krebs and worked the area coal mines. By 1920, his wife, Josephine, had given birth to Pauline (1918) and Christine (1920), and mines in Pittsburg County were in their last stages of grand-scale production. Labor troubles, combined with a shift from coal to oil and the Great Depression, curtailed mining at most locations. (Courtesy of Ron Mantegna.)

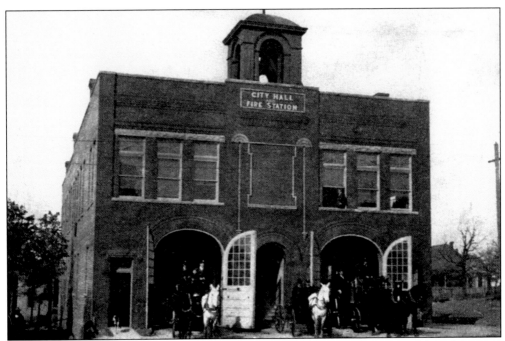

CITY HALL AND FIRE DEPARTMENT. The original city hall was at First Street and Grand Avenue, and the fire department was featured on a series of postcards over the years. This photograph depicts the department with horse-drawn wagons. In 1909, C. M. Davison was fire chief, with firemen B. A. Hogan and F. F. Sanders. (Courtesy of McHuston Booksellers.)

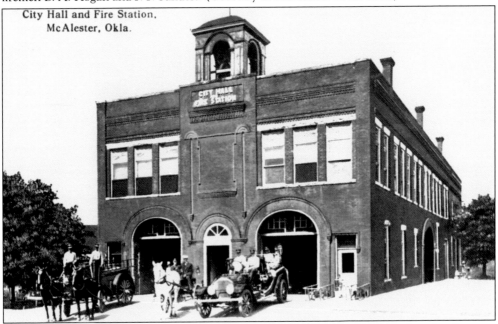

MCALESTER FIRE DEPARTMENT. The fire department had increased its numbers by the time of this image, which includes a horseless engine in addition to the two horse-drawn carriages. Motorized trucks were introduced after the beginning of the 20th century, and few communities in 1910 were able to afford the new inventions. (Courtesy of McHuston Booksellers.)

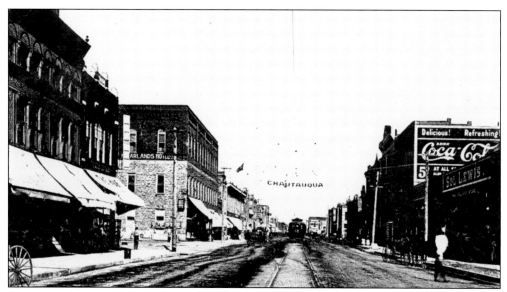

CHOCTAW AVENUE FACING EAST, 1909. The awning in the first block on the left reads, "the Hub," a clothing store operated by Herman Levin at 7 East Choctaw Avenue. Just beyond the intersection is McFarland's Hotel and Cafe, operated by Frederick McFarland. Rolling down the center of the dirt street is the trolley, which ran through the community and eastward to Hartshorne. (Courtesy of McHuston Booksellers.)

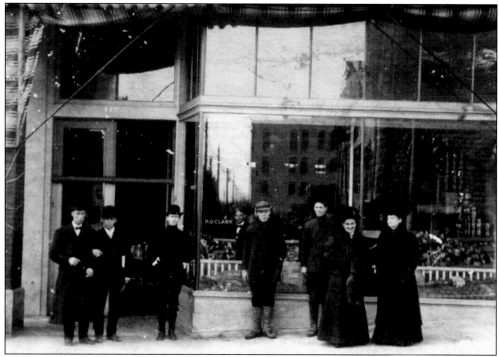

CLARK GROCERY STORE, 1909. The N. D. Clark grocery was located at 115 North First Street, and the effects of that steeply inclined street are visible in this image of unidentified patrons. Ohio native Newell D. Clark and his wife, Viola, left Kansas to open a grocery store in the Choctaw Nation, not long before statehood. (Courtesy of Steve DeFrange.)

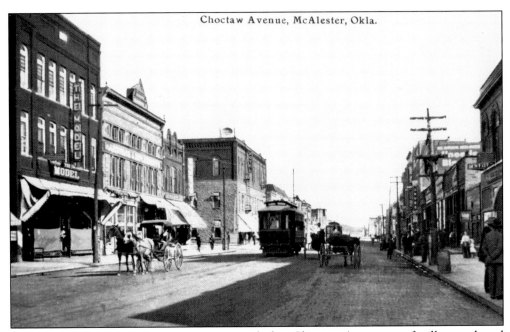

Choctaw Avenue, McAlester, Okla.

TROLLEY ON CHOCTAW AVENUE. It was years before Choctaw Avenue was finally paved, and the thin wooden wagon wheels often became mired in the mud. The Model at the left of this 1910 image was the establishment of Lewis Berlowitz, who offered "fine clothing at moderate prices." The area shown in this picture was a cornfield that was owned by Fritz Sittle as late as 1889. (Courtesy of Steve DeFrange.)

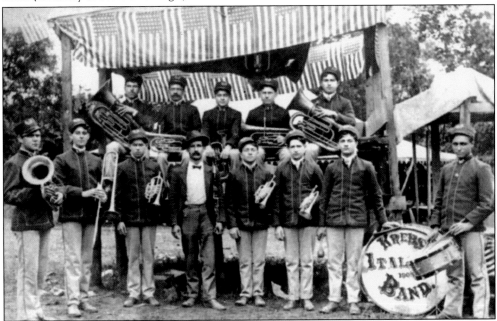

KREBS ITALIAN BAND, 1905. Isaia Lalli was the leader of this 13-piece brass band. The band members are, from left to right, (first row) Dave Franchone, Tony S. Farris, Nick DeFrange, Isaia Lalli, Angelo DeJacimo, Nick Cinocci, Lee Baradi, and Tony Fabriczo; (second row) Tom Carano, Tony Stizzi, Dominic Ross, Angelo Giacomo, and Ralph Nausch.

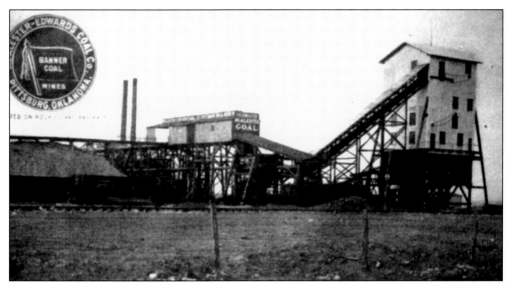

MCALESTER EDWARDS COAL COMPANY. Daniel Edwards and his son Thomas sank a mining shaft near Kiowa in 1899, and by 1902 the family had two mines in operation at the resulting community, first called Cowpers and renamed Edwards. The mines were sold in 1906 to a group incorporated as McAlester-Edwards Coal Company, which bought land and established a new townsite called Pittsburg nearer the mines. (Courtesy of Steve Defrange.)

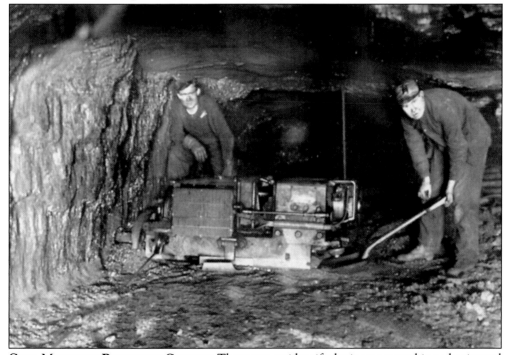

COAL MINERS IN PITTSBURG COUNTY. These two unidentified miners are working a horizontal shaft, typical of the county-wide operations shipping coal under a number of trade names. The McAlester-Edwards Company mine at Pittsburg also operated under the names Banner Coal Company and McAlester Coal and Mining Company but ceased all operations in 1941. Hodgens Coal Company was the final mine at Pittsburg, closing in 1954. (Courtesy of Steve DeFrange.)

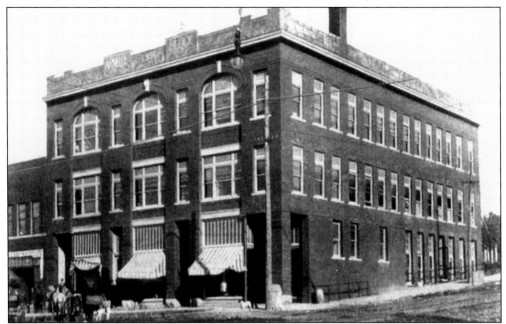

ARNOTE BLOCK BUILDING, 1910. Missouri native James S. Arnote was one of the capable attorneys who moved to South McAlester when the federal court was established. The impressive Arnote Block Building, often just called the Arnote Building, housed his law offices at 14 North First Street. Arnote and his wife, Stella, lived at 228 West Washington Street, and he served as city councilman representing Ward 4. (Courtesy of Steve DeFrange.)

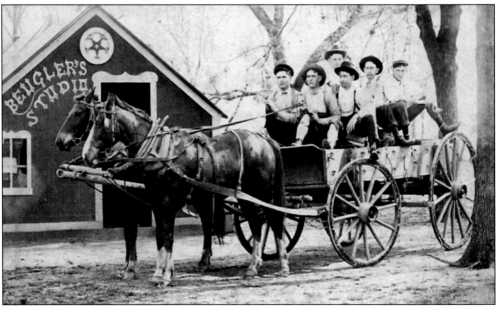

BEUGLER'S STUDIO, INDIAN TERRITORY. During the earlier days, smaller communities were forced to rely on itinerant photographers who traveled the country taking pictures. Pittsburg County had several studios, including Beugler's at Iron Bridge on Electric Avenue. A number of family portraits and photographs still exist bearing the stamp of Beugler's Studio. Frank Elliot is at the reins with a wagonload of unidentified passengers. (Courtesy of Steve DeFrange.)

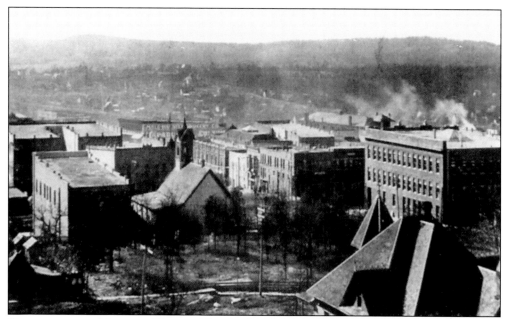

VIEW FROM THE MASONIC TEMPLE. This bird's-eye view of McAlester is from the early 1900s, looking toward the southeast. Tom Hale was president of the Hale Halsell Wholesale Grocery Company, which originally had a grocery on South Main Street. The Hale-Halsell Building is visible in the distance, at the left center of the photograph, a familiar sight even though the company relocated to Tulsa in 1969. (Courtesy of Steve DeFrange.)

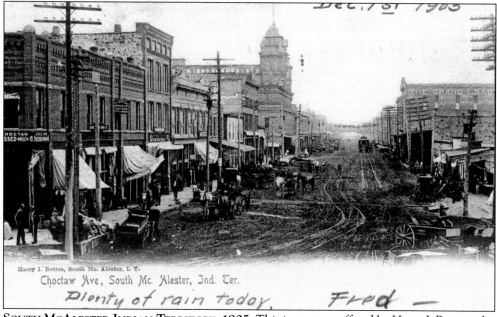

SOUTH MCALESTER INDIAN TERRITORY, 1905. This image was offered by Harry J. Bettes, who operated one of the earliest drug and sundries stores at 114 East Choctaw Avenue. The sender of this postcard noted the wet weather, and those making their way on Choctaw Avenue risked being bogged down in the mud. The street was eventually paved in the spring of 1906. (Courtesy of Richard Moody, Moody's Collectibles.)

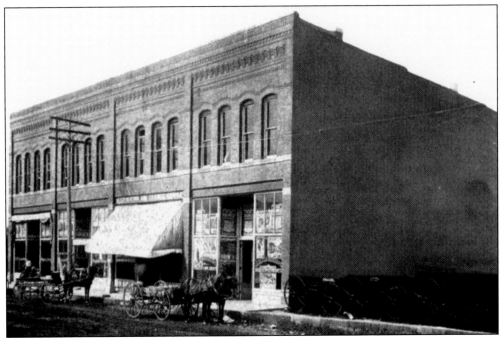

CAMBRON BUILDING AT SOUTH MCALESTER. James B. Cambron was a blacksmith and carriage dealer, located at 306–312 South Main Street. Rows of carriages are lined up along the edge of the building, ready to take on the rugged ruts of the town's dirt streets. Stephen F. and S. Adolphus Cambron worked as blacksmiths, and all three lived in a boardinghouse at 1000 South Seventh Street. (Courtesy of Steve DeFrange.)

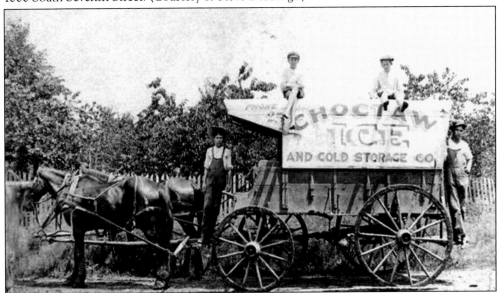

CHOCTAW ICE DELIVERY BOYS. This early-1900s image depicts a profession lost to the invention of the refrigerator. Ice wagons with deliverymen such as these unidentified workers carried products to homes and business. In 1905, wagon drivers for Choctaw Ice included W. Frank Daniels, Leonard Gabbert, James O. Goode, Fred D. Hawkins, Charles H. Hess, John W. Jennings, Oliver McGibeney, and George Saunders. (Courtesy of Steve DeFrange.)

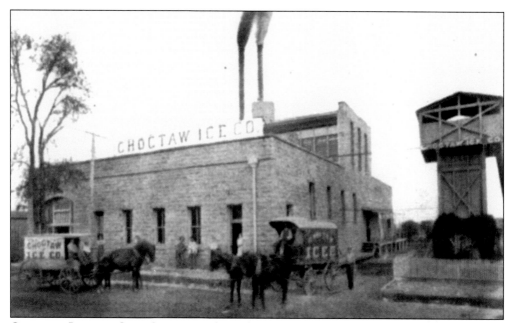

CHOCTAW ICE AND COLD STORAGE. The early ice-making process involved coal-driven boilers to condense ammonia as a refrigerant and is the reason smoke could be seen rising from an ice-manufacturing plant. Caleb W. Dawley served as president of the Choctaw Ice and Cold Storage Company, located in the building at 338–342 East Choctaw Avenue, with the business managed by Wesley S. Ambrose. (Courtesy of Steve DeFrange.)

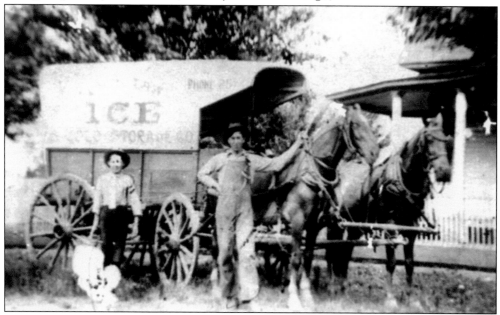

DELIVERY FROM THE ICE WAGON. Home deliveries came a couple of times a week for the metal-lined wooden icebox. Deliverymen used large tongs to carry the ice, which was shaved to fit the individual box, but usually 16 to 18 inches thick. An average block might weigh 50 to 75 pounds, but the unidentified man in the picture is listing only slightly under his burden. (Courtesy of Steve DeFrange.)

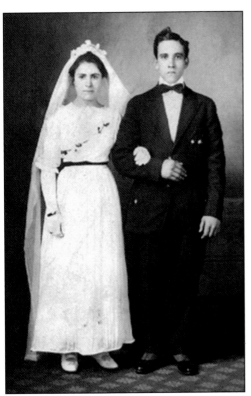

WEDDING DAY PORTRAIT. Italian immigrants Carl and Josephine Mantegna pose on their wedding day around 1917 in Krebs. They made a home in Second Ward, and Carl worked as a miner. The portrait was made by photographer Charles D. Webb, a Mississippi native who opened a studio at McAlester before 1920 and lived near Fourth Street and Kiowa Avenue with his wife, Carrie. (Courtesy of Ron Mantegna.)

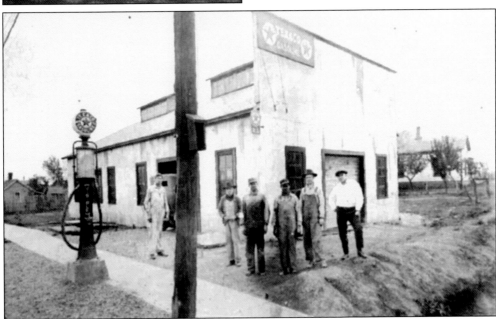

DEFRANGE BROTHERS GARAGE AT KREBS. James DeFrange immigrated from Carovilli, Italy, in 1881 and by 1920 had quit the mines to operate a grocery store at Krebs. His sons Nick, Robert, and Joseph left the mines to open a garage and station west of downtown Krebs. Shown from left to right are unidentified, James DeFrange, Robert DeFrange, Nick DeFrange, John Fabrizio, and Vincent Stevens. (Courtesy of Steve DeFrange.)

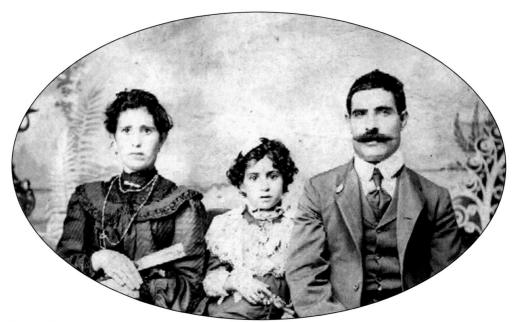

FIRST-GENERATION AMERICAN PORTRAIT. Although most immigrants intended to earn enough money to return to Italy, more than 75 percent remained in the United States, marrying and raising families. Joe and Carmella Randazzo, with daughter Ellen, pose for this portrait session around 1915. In addition to customs and cuisine, the Italians brought their faith with them, and Catholic parishes were established both at Krebs and McAlester. (Courtesy of Ron Mantegna.)

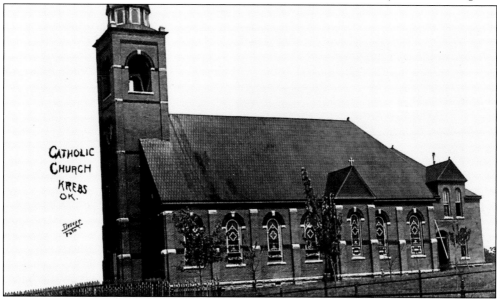

ST. JOSEPH'S CATHOLIC CHURCH, ESTABLISHED 1885. The original wood frame church burned to the ground in 1902. The beautiful 1903 structure built to replace the original is still in use at Krebs. A 1905 listing of area churches included East Star Baptist, First Baptist, St. John's Catholic, Christian, Christian Scientist, All Saints Episcopal, African Methodist Episcopal, African Methodist Episcopal Zion, Bowman Methodist Episcopal, Colored Methodist Episcopal, and the Methodist Episcopal Church South. (Courtesy of Steve DeFrange.)

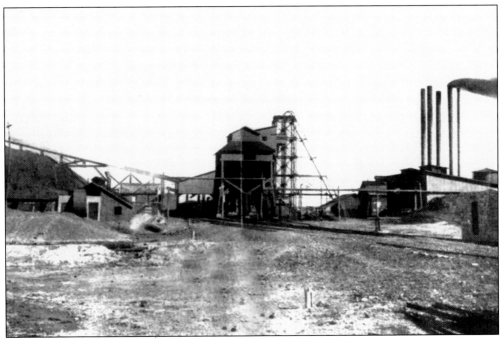

ROCK ISLAND NO. 8 MINE. Another community that quickly filled with immigrant workers was Hartshorne, named for railroad executive Charles Hartshorne. The Rock Island mine pictured here was one of the largest mines in Oklahoma, said to have a monthly payroll before 1920 in excess of $175,000 per month. The community mines also drew a large number of immigrants from Russia, Poland, and Eastern Europe. (Courtesy of Steve DeFrange.)

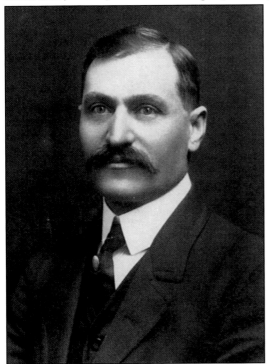

ITALIAN CONSULAR AGENT JOHN TUA. An early immigrant, John Tua was a successful businessman and was appointed as Italian consul to act on behalf of the many immigrants, recording deeds, writing wills, issuing passports and visas, and even selling steamship tickets to those returning to Italy. He married Netta Rosa Silotto, an Italian immigrant, and their sons were active in city government. (Courtesy of Steve DeFrange.)

PETE PRICHARD IN HIS KITCHEN.
Pietro Piegari came to Krebs with his
family in 1903 from San Gregorio
Magno, Italy, and renamed himself Pete
Prichard when he signed on with the
mining crews as an 11 year old in 1906.
At 21, a mine cave-in severely injured
Pete's leg. Unable to work the coal,
he began serving meals to the miners,
who found good eating at Pete's Place.
(Courtesy of Joe Prichard.)

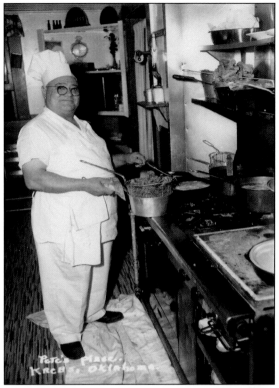

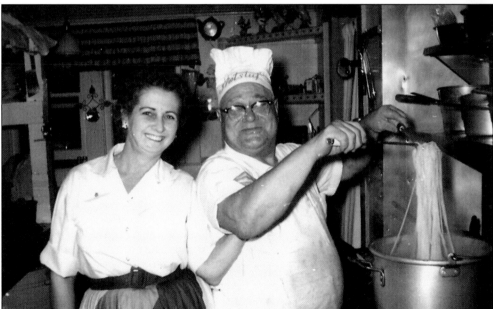

IN THE KITCHEN AT PETE'S PLACE. An unidentified employee is seen with restaurateur Pete
Prichard. In addition to the lunches prepared for mine workers, Prichard adapted a recipe for
Choc beer, derived from one produced by some members of the Choctaw Nation, which he began
to serve with his meals. In 1925, he officially opened a restaurant in his home, an operation still
in the Prichard family. (Courtesy of Joe Prichard.)

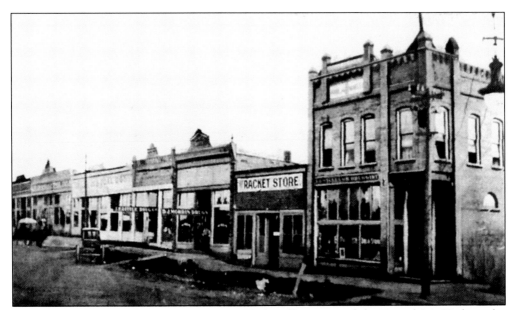

EAST MAIN STREET HAILEYVILLE, 1910. Haileyville is named for Daniel M. Hailey, who never resided there. Situated east of Krebs, Haileyville grew rapidly as immigrants primarily from Russia and Italy joined Choctaws and white laborers to work the mines. Haileyville and Hartshorne were sometimes called the Twin Cities for their close proximity and similarities, with Haileyville established in 1900 and the first mine leases signed by Daniel Hailey. (Courtesy of Steve DeFrange.)

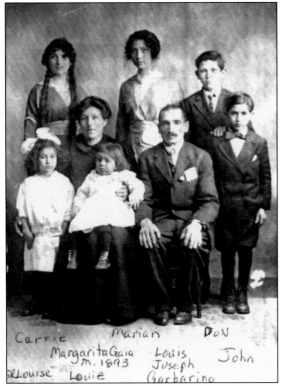

THE GABERINO FAMILY PORTRAIT. Louis Joseph Gaberino and Margaret Gaia married in 1893 at LeHigh, where their families settled after emigrating from Chialamberto, Italy. Louis worked the mines and later ran a grocery store. His sons were early employees of Oklahoma Tire and Supply and relocated to McAlester in 1935 when a new store opened, while daughter Louise joined a Catholic convent in Tulsa. (Courtesy of Lesley Brooks.)

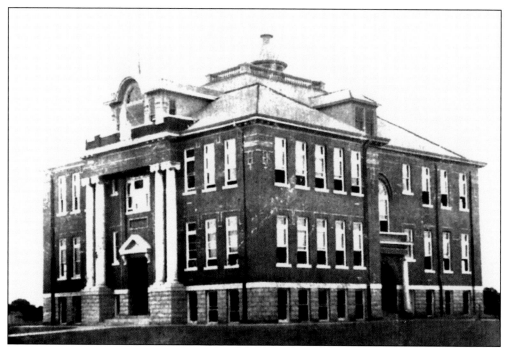

HARTSHORNE HIGH SCHOOL, 1910. The first school in Hartshorne was in a log house before 1897, but in 1909, construction was completed on this three-story brick structure with a complete basement. The upper two floors were used by junior and senior high school students, while grade school students used the bottom floor. Morgan T. Craft was principal of the school. (Courtesy of Steve DeFrange.)

KREBS HIGH SCHOOL. During the 1907–1908 coal mining boom years, a high school began operation at Krebs but was discontinued in 1912. After a donation of land by the Flesher family, high school education was reintroduced at Krebs after the construction of a new facility. Lynn Glover was the principal of the first public school in Krebs, which opened its doors in 1904. (Courtesy of Steve DeFrange.)

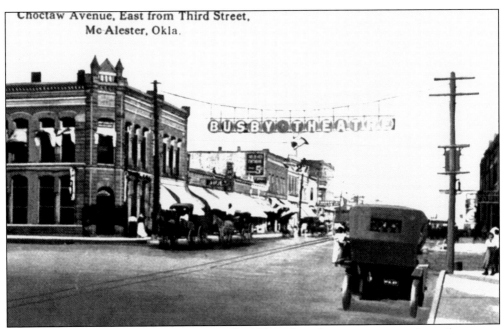

Choctaw Avenue, East from Third Street, Mc Alester, Okla.

BUSBY BANNER ON CHOCTAW AVENUE. By 1918, when this picture was taken, the streets were paved and automobiles had begun to make their first appearances on Choctaw Avenue, sharing the street with the horse-and-buggy rigs. The Busby Theater, indicated by the banner and pointing finger, was still in full swing as one of the top drawing theaters in the American Southwest. (Courtesy of Steve DeFrange.)

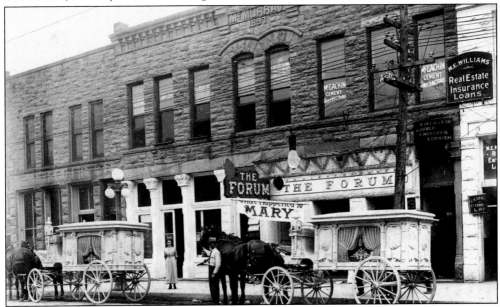

HEARSES AT THE MCMURRAY BUILDING. The Forum Theater is advertising *What Happened to Mary?*, the first motion picture serial produced in the United States, with episodes released monthly by Edison Studios beginning July 26, 1912. The McMurray Building additionally housed the law firm of Mansfield, McMurray and Cornish, the offices of McEachin Cement Contractors, and the law offices of David C. McCurtain and F. M. Taylor. (Courtesy of Lesley Brooks.)

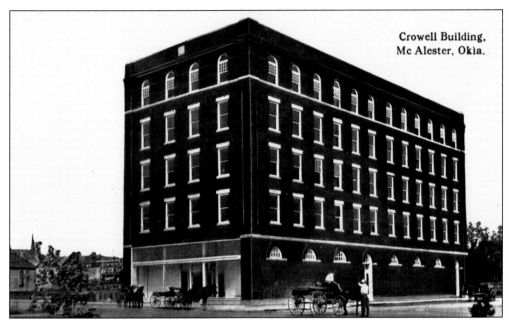

Crowell Building,
Mc Alester, Okla.

CROWL BUILDING AT MCALESTER. Lumberyard manager Smith Crowl came to McAlester in 1895, and in 1902, he opened a hardware store in the Lansdale Building at 15 East Choctaw Avenue. In 1912, he constructed a five-story "skyscraper" at Second Street and Cherokee Avenue, the county's first building of such height. Crowl's Diamond Hardware remained in the building until it was destroyed by fire in August 1981. (Courtesy of Richard Moody, Moody's Collectibles.)

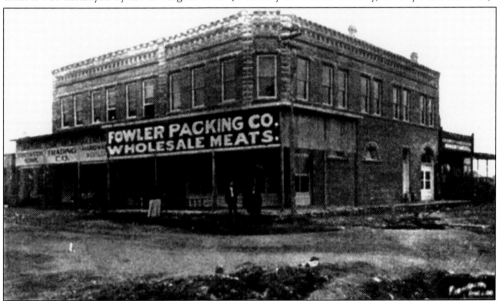

CHANEY-BECKER TRADING COMPANY. George M. Chaney and Leo Becker began their furniture store partnership in Krebs in 1890. In 1901, they moved into a South McAlester building at 217–221 South Main Street, which they shared for a short time with Fowler Packing Company. Chaney-Becker offered embalming services, and after Chaney bought out Becker, the funeral business became the primary concern as Chaney's Funeral Home. (Courtesy of Steve DeFrange.)

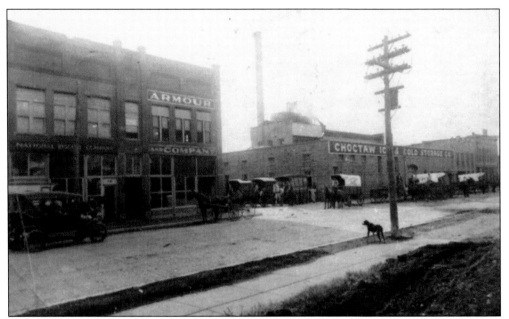

EAST CHOCTAW AVENUE IN MCALESTER. By 1900, Chicago-based Armour and Company had more than 12,000 refrigerated railcars shipping beef from its slaughterhouses located across the country. Its office relocated near the ice plant at 342 East Choctaw Avenue and was situated in the same building with the New Jersey–based National Biscuit Company, which became better known by its abbreviated form, Nabisco. (Courtesy of Steve DeFrange.)

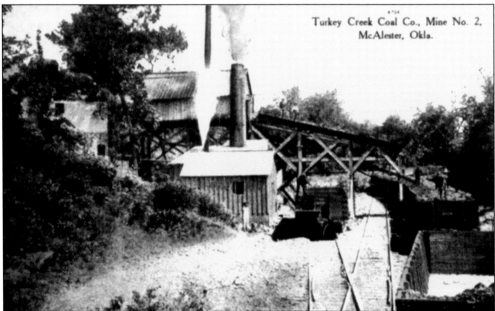

TURKEY CREEK COAL COMPANY. In 1902, the territorial government sent delegations to represent the territories at the 1904 St. Louis world's fair. From Tobucksy County, an exhibit of coal from the Turkey Creek Coal Company was displayed, with J. J. McAlester attending for McAlester and William Busby representing South McAlester. Several other Tobucksy County mines exhibited their products as well. (Courtesy of Steve DeFrange.)

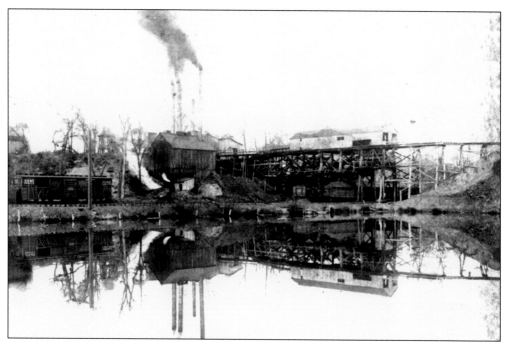

ADAMSON MINE LAKE. Ironically, water was a cause of many early-day difficulties for residents at Adamson, separated from the trade at McAlester by Gaines Creek, which was impassable after heavy rains. Early on, residents had to carry their own water or buy it from dealers who sold it by the barrel from wooden tanks pulled by teams of horses. Initially the mines were the only industry. (Courtesy of Steve DeFrange.)

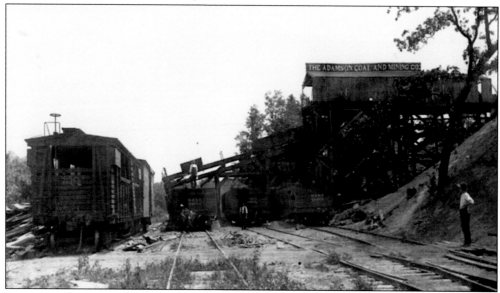

ADAMSON COAL AND MINING COMPANY. Peter Adamson came to the area from Tulsa before statehood, establishing coal mines and a church for the Latter Day Saints. By 1905, a post office was established at the growing town, which was named for Adamson, who also served as the first postmaster. At the height of its activity, Adamson was home to more than 5,000 residents. (Courtesy of Steve DeFrange.)

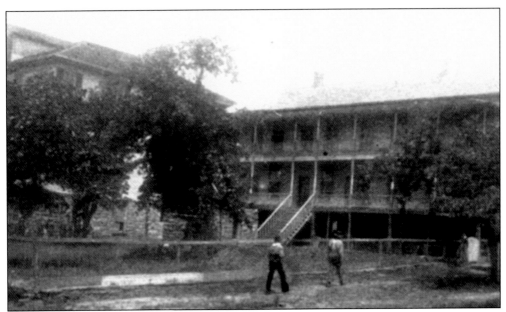

ALL SAINTS HOSPITAL. Although there were numerous general practitioners in the county, facilities were nonexistent for the continued treatment of major injuries, and the mining explosion at the No. 11 Mine at Krebs demonstrated a need for a local hospital. The All Saints Hospital was owned and operated by the Protestant Episcopal Church and was a charter member in 1920 of the Oklahoma State Hospital Association. (Courtesy of Steve DeFrange.)

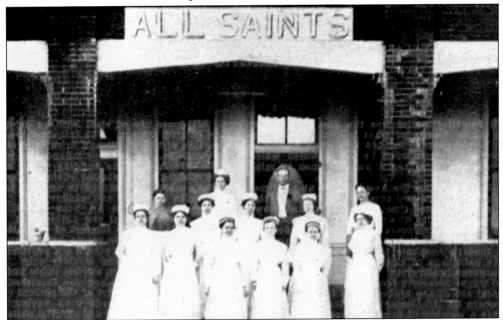

STAFF OF ALL SAINTS HOSPITAL, 1917. A nurses training program was included as part of the hospital operations at E Street and Choctaw Avenue, and several graduate nurses went to Europe to serve in World War I, including Effie Barnett, a member of the Choctaw Nation. She entered the Army Nurses Corps and arrived for duty in France in October 1918. (Courtesy of Steve DeFrange.)

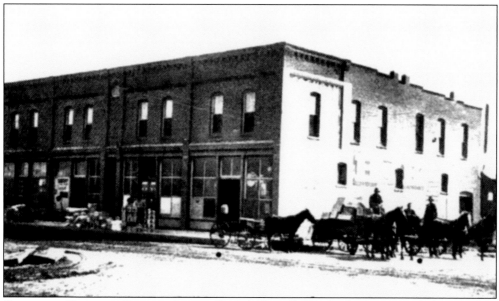

COCHRAN GROCERY SUPPLY. George C. and Caswell W. Cochran operated the Cochran Grocery Supply at Third Street and Choctaw Avenue, along with Roscoe L. Cochran. The Mississippi natives migrated to Texas and later moved to Indian Territory in 1898. By 1900, there were four wholesale grocery and produce companies operating in Tobucksy County, taking advantage of the rail service extending in all directions. (Courtesy of Steve DeFrange.)

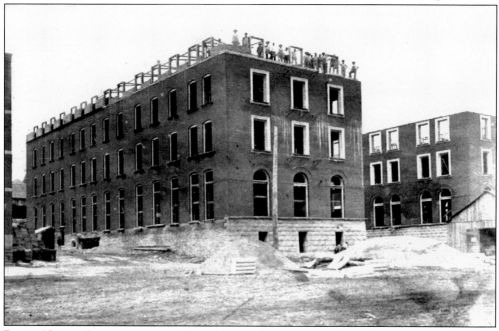

BUSBY HOTEL CONSTRUCTION. After enlisting the support of the public for the building of a hotel, William Busby pledged his own cash in 1904 and in the summer bought a plot of land that J. J. McAlester sold at a discounted price. Some 135 other residents donated money toward the construction of a first-class hotel, which Busby saw as the cornerstone of city growth. (Courtesy of McAlester Public Library.)

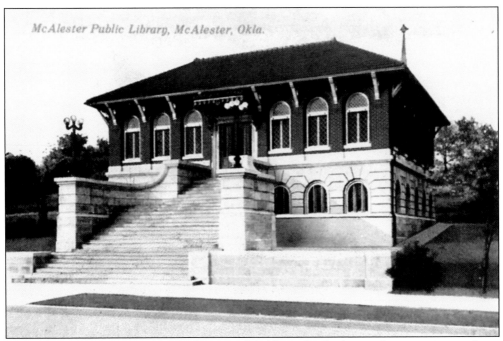

MCALESTER PUBLIC LIBRARY. The library at McAlester has had several incarnations and was situated at one time at 217 East Choctaw Avenue. In 1906, McAlester was one of eight towns in Indian Territory receiving grants from the Andrew Carnegie Library Program, which provided money toward the construction of a new library. The building was later razed after the library relocated to North Second Street. (Courtesy of Steve DeFrange.)

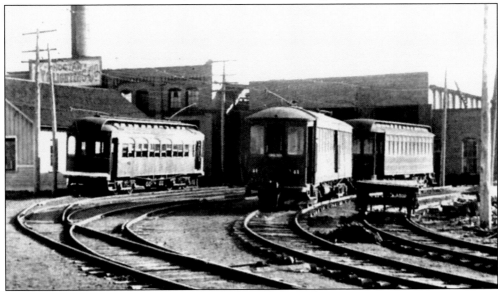

CHOCTAW RAILWAY AND LIGHTING COMPANY, 1901. Within a year of this photograph, the Indian Territory Traction Company was incorporated with the intention of connecting by rail the communities of North and South McAlester. Just a few years later, the light electrical rail service trolleys could be seen meandering between the two McAlesters and extending passenger service as far east as Hartshorne. (Courtesy of Steve DeFrange.)

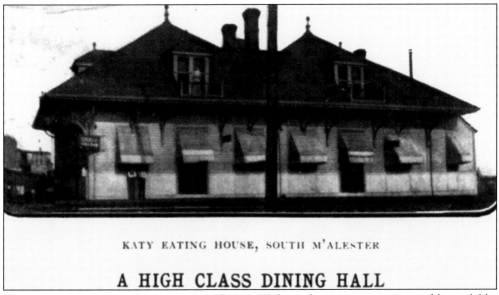

KATY EATING HOUSE, SOUTH M'ALESTER

A HIGH CLASS DINING HALL

ADVERTISING FLYER FOR KATY EATING HOUSE. With ample passenger service readily available, all types of businesses found a steady supply of clientele waiting for the train arrivals and departures. William J. Carr managed the Katy Dining Room at the tracks and Choctaw Avenue and was just one of several establishments in South McAlester promoting themselves as "high class." (Courtesy of Steve DeFrange.)

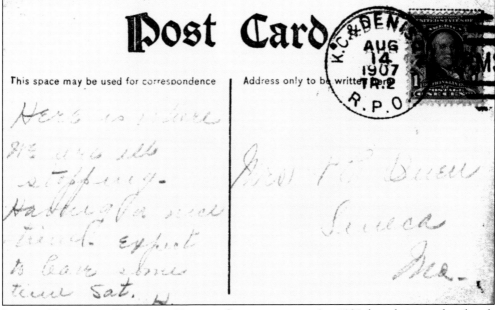

INDIAN TERRITORY RAILROAD POSTAL CANCELLATION. An 1838 law designated railroads as postal routes, and by 1870 railway post offices (RPO) were commonplace on nearly every railroad. Clerks rode specially designated RPO cars, sorting mail while the train was underway. This South McAlester Indian Territory postcard had a rail cancellation on the line from Kansas City to Denison, Texas. Airmail and interstates ended the system. (Courtesy of McHuston Booksellers.)

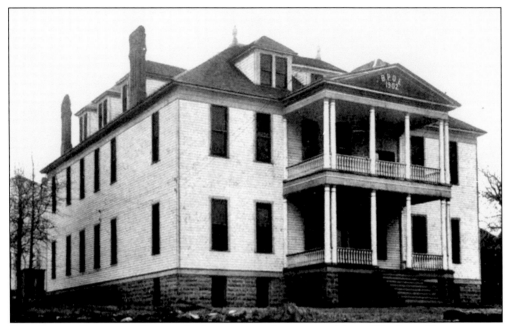

ELKS LODGE BUILDING. During the boom years, the communities of Pittsburg County moved from providing only the necessities to offering those amenities found in larger cities. By the early 20th century there were already several fraternal and social organizations, and the Benevolent and Protective Order of Elks constructed Lodge No. 533 in 1902 at 211 East Grand Avenue. Dr. Daniel Hailey served as president in 1905. (Courtesy of Steve DeFrange.)

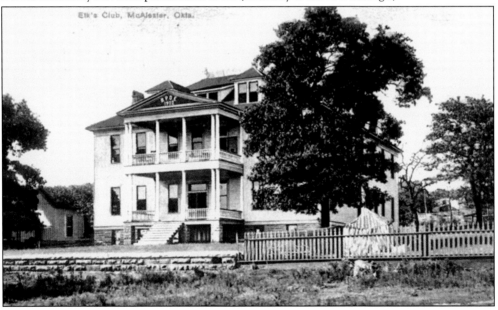

ELKS LODGE POSTCARD. In addition to the Elks lodge, McAlester served as regional or national headquarters for a number of groups and societies. During the period before statehood, such organizations included Civil War veterans' groups representing both the North and the South, the Ancient Order of United Workmen, the Fraternal Order of Eagles, the Knights of Pythias, the Knights of the Maccabees, and others. (Courtesy of Steve DeFrange.)

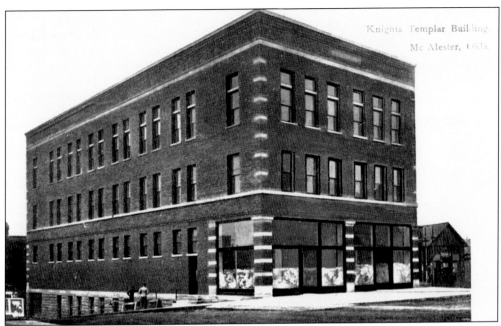

KNIGHTS TEMPLAR BUILDING. Even so-called secret societies found publicity, such as city directories and postcards like this one depicting the building on Grand Avenue. With fewer solitary diversions, residents socialized in homes and met as groups as part of the early-day entertainment and recreation. Several Masonic groups met at the Scottish Rite Temple, and an African American society met at Curry's Hall at Second Street and Delaware Avenue. (Courtesy of McHuston Booksellers.)

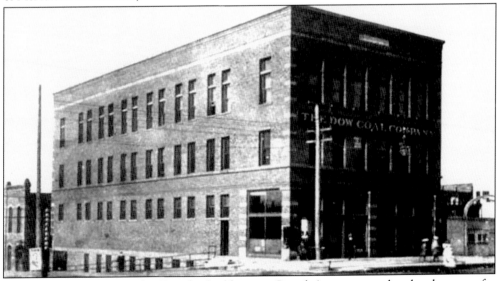

DOW COAL COMPANY. The Templar building on Grand Avenue served as headquarters for the Dow Coal Company, which William Beaty managed for the Milby-Dow Coal Company. The company moved from Choctaw Avenue to Grand Avenue after 1905 but entered bankruptcy in February 1915. The community of Dow southeast of McAlester sprang from the tent camps of miners in 1892 at the mining site of coal producer Andrew Dow. (Courtesy of Steve DeFrange.)

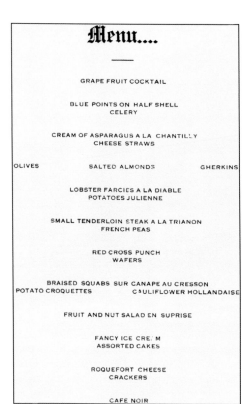

Menu....

GRAPE FRUIT COCKTAIL

BLUE POINTS ON HALF SHELL
CELERY

CREAM OF ASPARAGUS A LA CHANTILLY
CHEESE STRAWS

OLIVES SALTED ALMONDS GHERKINS

LOBSTER FARCIES A LA DIABLE
POTATOES JULIENNE

SMALL TENDERLOIN STEAK A LA TRIANON
FRENCH PEAS

RED CROSS PUNCH
WAFERS

BRAISED SQUABS SUR CANAPE AU CRESSON
POTATO CROQUETTES CAULIFLOWER HOLLANDAISE

FRUIT AND NUT SALAD EN SUPRISE

FANCY ICE CREAM
ASSORTED CAKES

ROQUEFORT CHEESE
CRACKERS

CAFE NOIR

MASONIC SOCIETY DINNER MENU. Newspaperman Oscar Ameringer described the 1907 Indian Territory population he encountered as "worse fed, worse clothed, worse housed" than Chicago meatpackers. Tobucksy County at that time enjoyed coal-driven prosperity, and this menu features offerings such as lobster, tenderloin steak, and "braised squabs sur canapé au cresson." The dinner was held by Order of the Red Cross of Constantine, a Masonic sect. (Courtesy of McHuston Booksellers.)

DINNER MENU AUTOGRAPH PAGE. An early-day custom involved collecting dinner party signatures on a special page of the printed menu. The autograph page of the Red Cross of Constantine dinner features signatures of Daniel and Helen Hailey, William and Sarah Busby, Jay G. and Lela Puterbaugh, and noted attorney William Hayes Fuller, all of McAlester. The menu dates between 1902 and 1913. (Courtesy of McHuston Booksellers.)

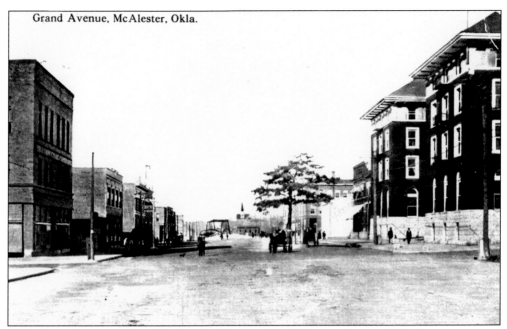

Grand Avenue, McAlester, Okla.

LOOKING WEST ON GRAND AVENUE. Before South McAlester, this site held a log cabin with a pine tree beside it, and the tree remained in the street until it eventually died. The Busby Hotel is on the right, and across the street is the Dow Coal Company Building. Mid-block on the left, beneath the flag, is an early location of the S. H. Kress store, part of the national five-and-dime department store chain begun in 1896. (Courtesy of McHuston Booksellers.)

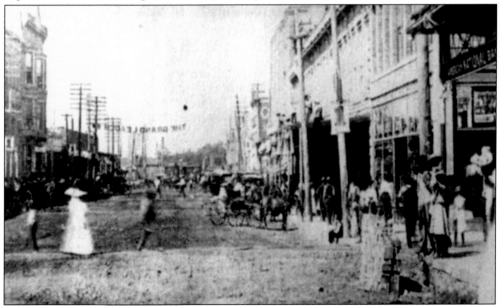

LOOKING WEST ON CHOCTAW AVENUE, 1905. A block south of Grand Avenue, Choctaw Avenue bustled with activity. The awning at the right sheltered the American National Bank at Second Street and Choctaw Avenue, whose officers included J. J. McAlester as president and William Busby and Elmer C. Million as vice presidents. In March 1906, J. J. McAlester announced plans to pave this block out of his own pocket. (Courtesy of Steve Defrange.)

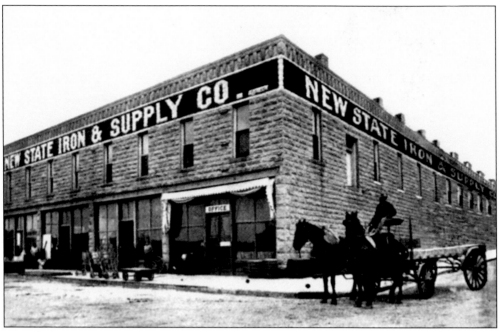

NEW STATE STEEL AND SUPPLY. South McAlester experienced phenomenal growth after the dawn of the 20th century and rivaled Oklahoma City as the most-populous town in the Twin Territories. By 1900, less than two months after incorporation as a city, resources included the iron and steel foundry, two banks, 11 churches, four grocery wholesalers, a cotton compress, an ice plant, a macaroni factory, and two brickmaking plants. (Courtesy of Steve DeFrange.)

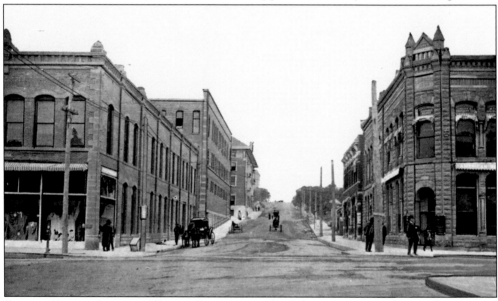

SECOND STREET LOOKING NORTH. From just south of the intersection of Second Street and Choctaw Avenue, this early postcard shows the new home of the American National Bank on the right and the New McAlester Building on the left, featuring a department store. Up the dirt street is the Templar-Dow Coal Building, and beyond on the left is the Busby Hotel. This image predates the paving of Choctaw Avenue in 1906. (Courtesy of McHuston Booksellers.)

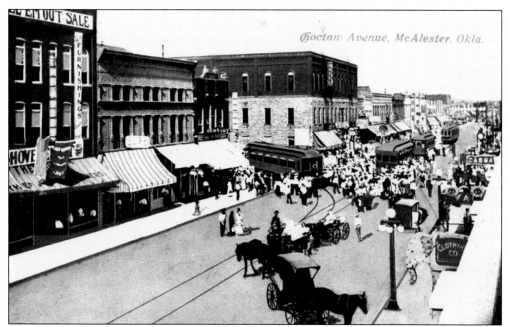

CHOCTAW AVENUE LOOKING EAST. The appearance of Choctaw Avenue greatly improved with the brick paving in 1906, which preceded the laying of the trolley rails. This image features old and new, with horse and buggies alongside the passenger rail service, amid a large gathered crowd. Louis Berlowitz, proprietor of the Model clothing store in the building at the far left, advertised a "Shove 'em Out Sale." (Courtesy of McHuston Booksellers.)

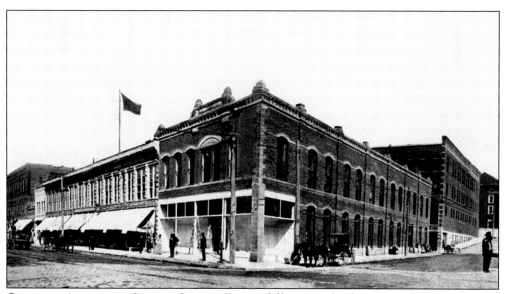

CHOCTAW AVENUE AT SECOND STREET. From a different angle, this image of the intersection of Second Street and Choctaw Avenue features the new McAlester building. Although he was forced to buy his way into South McAlester, the town's namesake became the largest property owner on Choctaw Avenue, and his intention to personally pay for the paving prompted all other business owners on the block to contribute. (Courtesy of McHuston Booksellers.)

KREBS FIRE, 1911. Fires plagued Krebs, and an August 19, 1911, blaze claimed nearly the entire district. Dynamite leveled a house to create a gap, halting the spreading flames as shop owners emptied the contents of their stores into the streets. Buildings from the opera house to Washington Avenue were lost. This photograph was taken from the site of the current post office. (Courtesy of Steve DeFrange.)

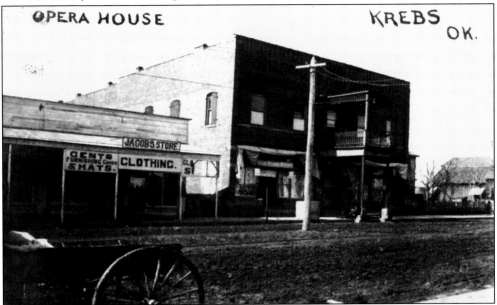

KREBS OPERA HOUSE, 1903. This opera house was constructed in 1902 to replace the previous theater, which burned to the ground in a fire on January 16, 1902. By the time of this photograph, tracks for the electric interurban trolley were already in place along the unpaved Main Street. Next door to the opera house, Jacob's Store featured "Gent's Clothing, Furnishing Goods & Hats." (Courtesy of Steve DeFrange.)

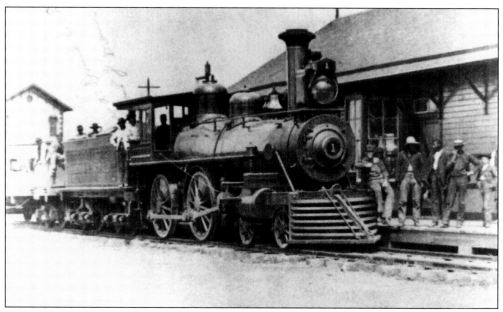

KREBS TRAIN DEPOT. The Katy locomotive was called the *Nellie* and is featured in one of the oldest known photographs of the Krebs business district. In the right side of the locomotive cabin are conductor Andy Drumb (left) and engineer J. Mann. This east-west branch of the Katy line extended from McAlester through Krebs and Hartshorne to Wilburton. (Courtesy of Steve DeFrange, Krebs Heritage Museum.)

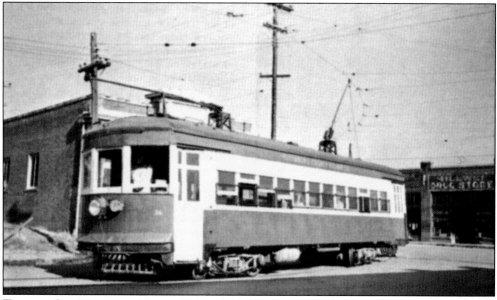

TROLLEY CAR NO. 36 AT KREBS, 1945–1946. Heading to Washington Avenue is the Pittsburg County Railway Company's trolley car preparing to make the left turn in front of Millwee Drug Store. Operated by the electric company at McAlester, the streetcar line began operations in the late 1890s and had extended as far as Hartshorne by late 1904. The line ceased operation in 1947. (Courtesy of Steve DeFrange, Krebs Heritage Museum.)

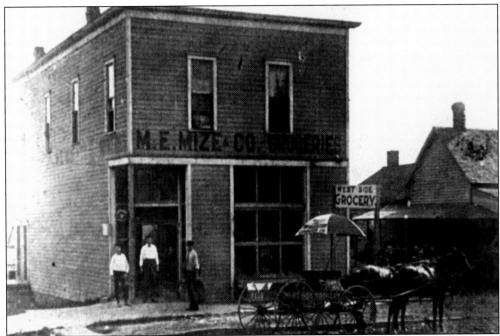

MIZE WESTSIDE GROCERY. From Crooked Creek, Kentucky, Harrison Mize came to Indian Territory around 1900 and opened the Mize Hotel west of the tracks on Choctaw Avenue but died before 1905, leaving the hotel in the hands of his wife, Sabrina. Their son, Milton Eugene Mize, worked as a bookkeeper for a local oil company, and he and his wife, Hattie, operated the Mize Westside Grocery. (Courtesy of Steve DeFrange.)

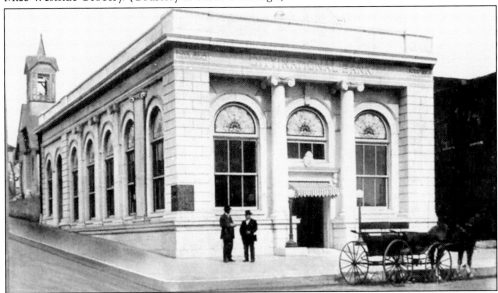

CITY NATIONAL BANK. By 1905, McAlester had four banks in operation, including the City National Bank at 105 East Choctaw Avenue. Capital and Surplus was valued at $55,000 under the direction of bank president Daniel M. Hailey and vice president James S. Arnote. Behind the bank, on North First Street, is an early wooden church building, one of 11 congregations in the young town. (Courtesy of Steve DeFrange.)

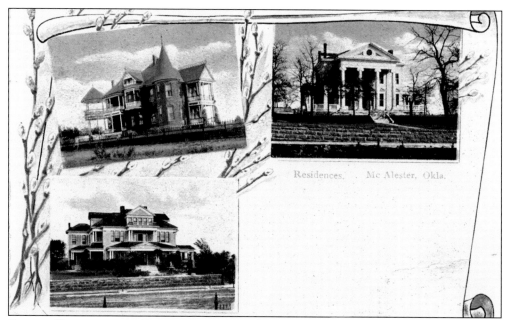

DROVER PHOTOGRAPHY POSTCARD. In the early 20th century, Herman H. Drover was one of several pioneer photographers to operate a studio in what was then Tobucksy County, Indian Territory. A number of his portraits remain, as do his photographic postcards from that era. By 1905, Drover had partnered with John M. Gannaway and worked from a studio at 13 East Choctaw Avenue. (Courtesy of McHuston Booksellers.)

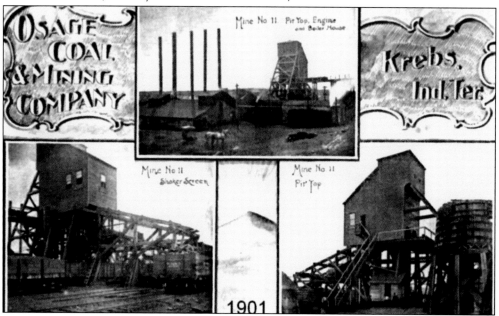

OSAGE COAL POSTCARD. Similar to the postcard issued by the Drover Studio, this 1901 card was produced by the St. Louis Photograph Engraving Company. Osage Coal and Mining Company was owned by William Busby, who originally worked as a salesman for the Choctaw, Oklahoma and Gulf Railway. When he succeeded in selling more coal than the company could produce, Busby became a coal operator himself. (Courtesy of Steve DeFrange.)

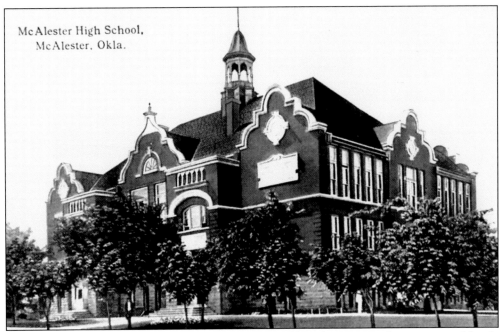

McAlester High School,
McAlester, Okla.

ORIGINAL MCALESTER HIGH SCHOOL POSTCARD. Public education in the county could only begin after North McAlester and South McAlester were incorporated in 1899 and taxes could be supported by city property taxes. There were 12 graduates in the 1903 first high school class. This brick building replaced a smaller original wooden structure but was consumed by fire in 1919. (Courtesy of Steve DeFrange.)

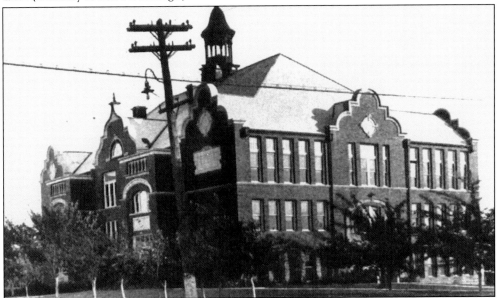

ORIGINAL MCALESTER HIGH SCHOOL PHOTOGRAPH. Public schools opened in McAlester on September 12, 1900, with William Gay as the first superintendent. In the years before statehood, grade school children were taught in wooden two-room schoolhouses that were constructed in each of the four wards of the city. Those structures were replaced after 1907 by brick buildings that were constructed on the same sites. (Courtesy of McAlester Public Library.)

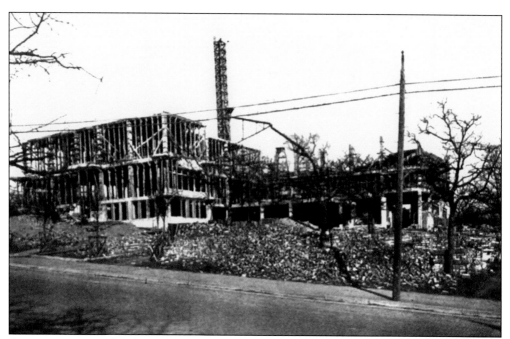

CONSTRUCTION OF MCALESTER HIGH SCHOOL. Before the inception of public schools and the construction of the McAlester High School building, educations could be had by subscription to a private school. The Presbyterian Church operated an academy in the county as early as 1888, with Edmond Doyle as headmaster. Many of the local grade schools would later bear the names of the pioneers of county education. (Courtesy of McAlester Public Library.)

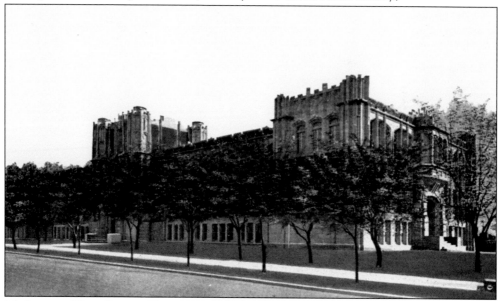

MCALESTER HIGH SCHOOL POSTCARD. Published by the W. E. Edwards Bookstore in McAlester, the image depicts the completed building constructed to replace the original high school that was destroyed by fire in 1919. The school was completed on the site of the original school, and the distinctive architecture of the building reflects an earlier time and remains as part of the area heritage. (Courtesy of McHuston Booksellers.)

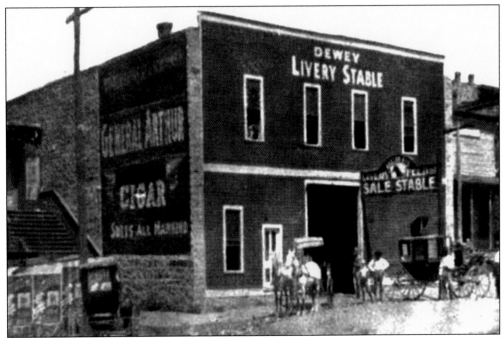

DEWEY LIVERY STABLE, BEFORE 1906. The Simpsons had several enterprises between Main and First Streets on Choctaw Avenue. Daniel B. Simpson and William Townsend were proprietors of the Dewey Livery Stable at 8–10 North First Street. Around the corner, Hugh Simpson operated a Main Street general store—Simpson, Wood and Company—with William Wood and James Whitehead. Simpson and Wood Dry Goods was at 34 East Choctaw Avenue. (Courtesy of Steve DeFrange.)

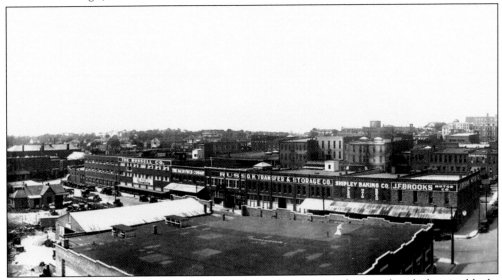

LEFT PANORAMIC VIEW, AROUND 1925. Within a dozen years after statehood, the city blocks adjacent to Choctaw Avenue and east of Main Street filled with a variety of buildings and businesses, many of which became McAlester fixtures over the next 50 to 75 years. Some changed locations, such as Shipley Baking Company, which was established at Fort Smith in 1921 by brothers Harry and Garvin Shipley. (Courtesy of Lesley Brooks.)

THE LUTZ BUILDING AND HOTEL. One of the early hotels was operated by John Lutz, who was born in 1860 in Pennsylvania to German parents and married a Scottish immigrant named Kate. The couple came to Indian Territory around 1895 with their children John, Margaret, and Lucy to open and operate the Central Hotel at 1–3 Krebs Avenue. Kate Lutz was widowed by 1910. (Courtesy of Steve DeFrange.)

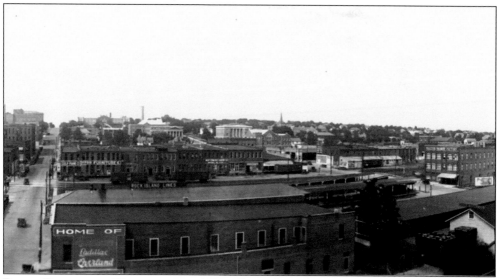

RIGHT PANORAMIC VIEW, AROUND 1925. The wide-angle image was taken from the roof of a Second Street building south of Choctaw Avenue, with several impressive structures in the distance, including the federal building. The Studebaker and Cadillac dealership also offered Overland cars, which ended production in 1926. Business names on the backs of buildings allowed visibility by rail passengers on the adjacent Rock Island line. (Courtesy of Lesley Brooks.)

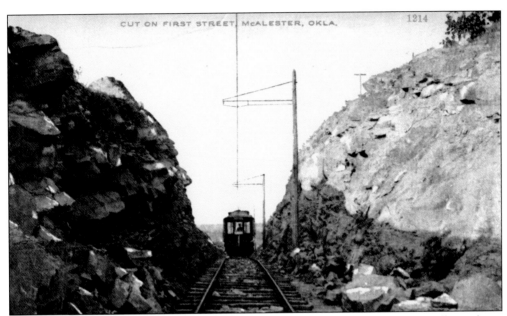

TROLLEY CUT ON FIRST STREET. Running steel wheels on steel rails works most effectively on flat terrain, and steep inclines cause wheels to slip. The steepest inclines north of downtown McAlester were those between Main Street and Third Street, north of Choctaw Avenue. A major excavation was undertaken to lower the incline, allowing the passenger-loaded trolleys to pass through the hill rather than climbing over it. (Courtesy of McHuston Booksellers.)

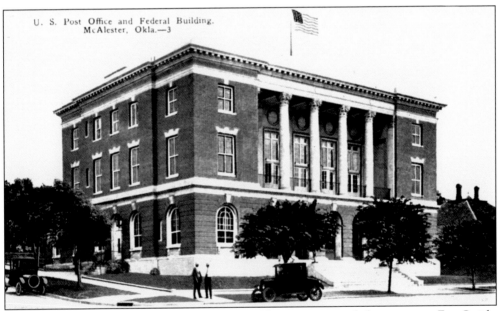

UNITED STATES FEDERAL BUILDING POSTCARD. The nearest nontribal court was at Fort Smith, Arkansas, lending to the lawless nature to the Indian Territories. Edwin Chadick petitioned Congress for a court at McAlester, promising free rooms for attorneys and court officials at his Kali-Inla Hotel. Despite the looming financial difficulties of the hotel, the court was approved, and an impressive building was constructed on Grand Avenue. (Courtesy of McHuston Booksellers.)

Four

COL. WILLIAM BUSBY

Although William Busby held no official military rank, he came to be called colonel out of respect. He was a first-generation American, born in 1856 in Pennington, New Jersey, to an English father and an Irish mother. The family moved to McCune, Kansas, when he was young, and despite growing up in poverty and without formal schooling, his industriousness and ethics provided for his later success.

From a grain business at McCune, Busby took charge of a coal office at Parsons, Kansas, selling coal for the Choctaw, Oklahoma and Gulf Railway. At six feet three inches tall and some 250 pounds, Busby's appearance and dynamic personality contributed to his being elected mayor of Parsons. He sold more coal than the mines produced, resulting in a coal-producing venture that would greatly affect the young communities of what was then Tobucksy County, Indian Territory.

His earnings would have amassed a fortune, but Busby instead invested heavily in a quality infrastructure to serve the towns. Finding the telephone service lacking, he bought the company and purchased new equipment. He bought the electric company and trolley, and with his financing and leadership, created a line that drew the interest of other cities. He constructed a hotel and believing strongly in social arts and culture, built a world-class theater.

While the founding of Pittsburg County came as the result of actions by many early settlers, it may be argued that Busby's actions during his 10-year residency at McAlester created the meteoric growth that allowed continued prosperity while so many other communities suffered at the decline of the coal industry. At the time of his death at age 59, McAlester's population trailed only Oklahoma City's, and as historian Thurman Shuller, M.D., observed in a 1996 address, "one has to wonder what the city of McAlester might have become" with Busby's continued leadership.

At Busby's death, McAlester "lost its vision," and the man effectively became lost to history. There is no public monument, building, or statue to honor William Busby, and only a single initial on a single building to indicate he was ever present.

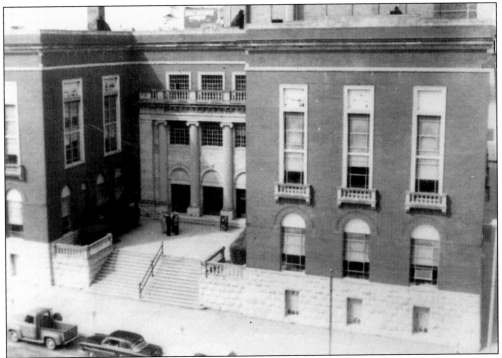

PITTSBURG COUNTY COURTHOUSE, 1955. William Busby's magnificent building on Grand Avenue lasted less than 20 years as the Busby Hotel before it was destroyed by fire in 1924. In the 17 years since statehood, Pittsburg County had yet to construct a courthouse and the building was acquired and given new life in 1926, when it was placed into service as the Pittsburg County Courthouse. (Courtesy of Lesley Brooks.)

BUSBY HOTEL AT COMPLETION. The kickoff campaign for the hotel financing was announced June 18, 1904, and J. J. McAlester provided the land for the building, which he sold at a discount to William Busby, who pledged his own money and challenged others to contribute. Some 135 residents managed to raise only $1,750 for the project, leaving almost the entire project financing to Busby. (Courtesy of McHuston Booksellers.)

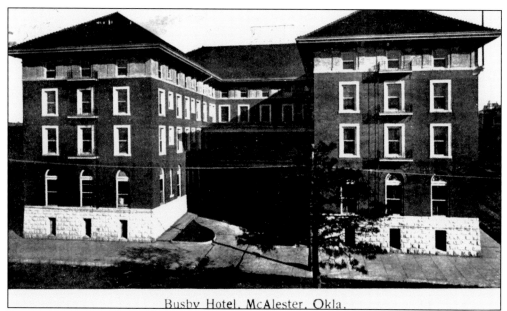

Busby Hotel, McAlester, Okla.

BUSBY HOTEL POSTCARD. The new hotel offered paved sidewalks and an interior courtyard, but Grand Avenue was unpaved. Although the tree in the foreground appears to be across the street, it was actually in the near center of Grand Avenue, a relic from the earliest days of the county. William Busby constructed one of the most impressive homes in the town, situated on West Monroe Street. (Courtesy of McHuston Booksellers.)

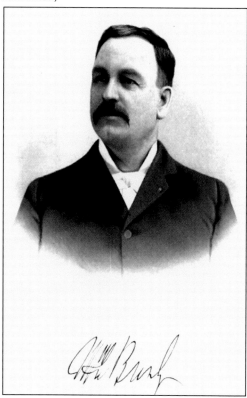

PORTRAIT OF WILLIAM BUSBY. From a Kansas wood hauler to mayor of Parsons, Kansas, William Busby brought his own brand of energy and insight to the Indian Territory and planted the seeds of arts and culture in a rough-and-tumble southwest mining town. Few aspects of Pittsburg County's development were beyond the impact of Busby's influence, and some of his accomplishments still stand, even if unrecognized. (Courtesy of McHuston Booksellers.)

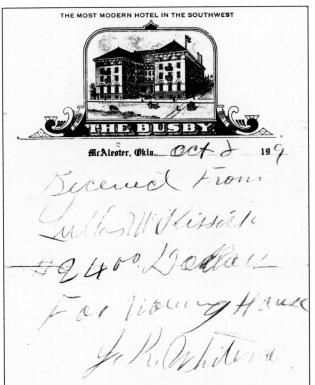

THE MOST MODERN HOTEL IN THE SOUTHWEST

THE BUSBY.

McAlester, Okla., _Oct 2_ 19 9

Received From

little M Kissick

$240° Dollars

For Viewing House

J. R. Whitera

BUSBY HOTEL STATIONARY.
Proclaiming it as "the Most Modern Hotel in the Southwest," there is no doubt the Busby rivaled any of the nation's finest. What it lacked in size compared to metropolitan United States hotels, it met or surpassed with amenities. After the completion of the Busby Theater, a passage from the hotel allowed guests to visit the theater without being exposed to weather elements. (Courtesy of McHuston Booksellers.)

ENVELOPES FROM THE BUSBY HOTEL. The formal opening of the Busby came in December 1905, although the hotel had hosted guests for some two months. More than 700 attended the festivities for speeches and dancing and a chance to view the splendor designed by architects who had toured the country seeking ideas from the best hotels. The Busby had four floors and 162 guest rooms. (Courtesy of McHuston Booksellers.)

70

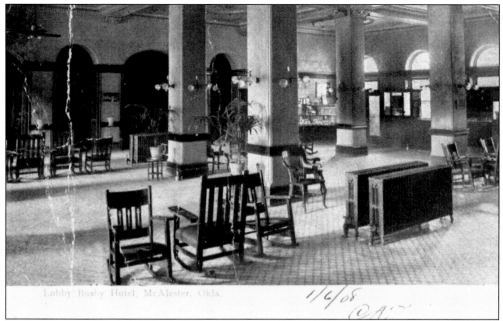

BUSBY HOTEL LOBBY. This photographic postcard of the Busby Hotel's interior was dated just weeks after Oklahoma statehood, with a glimpse of the tiled lobby, complete with rocking chairs and freestanding radiators. The desk and a gift counter were located near the front doors. It was said that the Busby Hotel featured more electric lights throughout its interior than all the rest of the town. (Courtesy of McHuston Booksellers.)

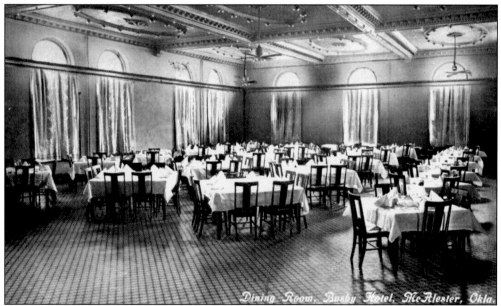

DINING ROOM AT THE BUSBY. This photographic postcard from 1910 shows tables and chairs to accommodate nearly 100 guests in the dining room at the Busby Hotel, and edges of several other tables indicate there were more tables than appear in the image. The card's sender, a guest from Texas, wrote, "This is where Charlie and I are getting on the outside of a good dinner." (Courtesy of McHuston Booksellers.)

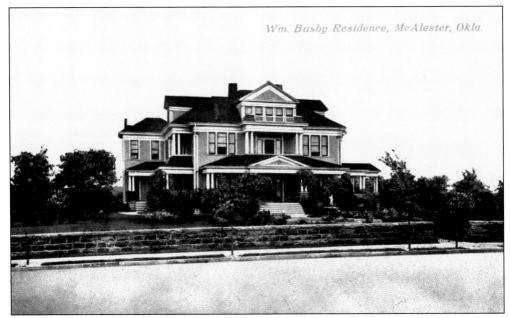

Wm. Busby Residence, McAlester, Okla.

HOME OF WILLIAM BUSBY. As part owner of a Tobucksy County mine, William Busby maintained his residence in Parsons, Kansas, where he served as mayor. After obtaining controlling interest in the Osage mine, he moved his family to South McAlester and built a home in an area that became known as Busby Heights. He eventually became the largest coal operator in the county, employing some 3,500. (Courtesy of McHuston Booksellers.)

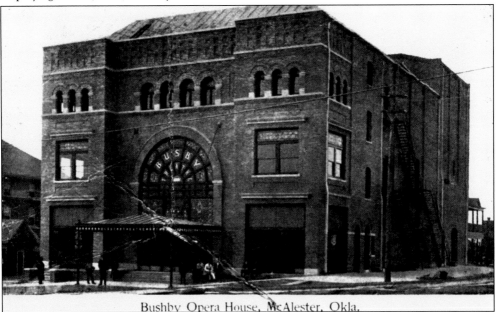

Bushby Opera House, McAlester, Okla.

BUSBY THEATER POSTCARD. The caption reads, "Bushby Opera House," but the lettering on the glass over the front door clearly identifies it as the Busby Theatre, using the old-world spelling of the word. Considered by some as William Busby's crowning achievement, the Busby Theatre opened to great fanfare on March 13, 1908, with a performance by nationally known entertainer De Wolf Hopper. (Courtesy of McHuston Booksellers.)

PORTRAIT OF DE WOLF HOPPER. On opening night De Wolf Hopper faced a sold-out house and first recited the poem *Casey at the Bat* before performing in the comic opera *Happyland.*. Tickets ranged from $2 downstairs to $1 for the upper gallery. A newspaper account reported that Hopper favorably compared the new venue to those in New York and Chicago. (Courtesy of Library of Congress.)

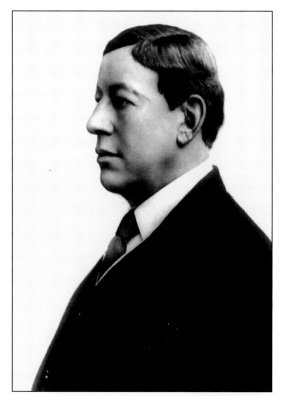

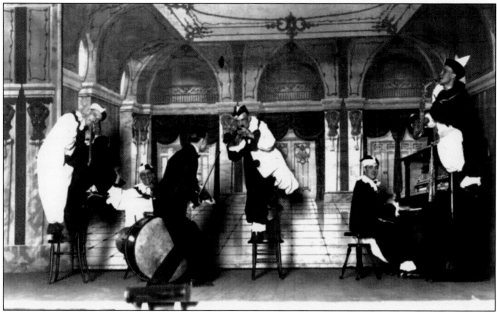

CY PERKINS BAND AT THE BUSBY. At the height of its popularity, the Busby Theatre offered top name acts, local performances, and regional touring groups and its location between Dallas and Kansas City offered performers a chance to stay at the Busby and play a "one-nighter" at the adjacent theater. Many national acts arrived in special train cars that carried the stars and their sets. (Courtesy of Steve DeFrange.)

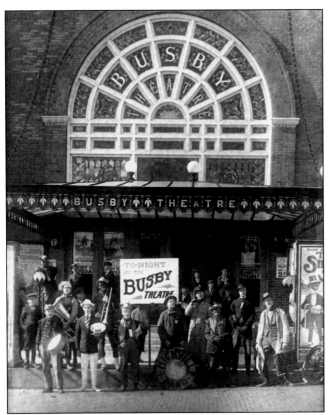

CY PERKINS HICKSVILLE BAND. The construction of the Busby coincided with the refining of the vaudeville circuit, when impresarios discovered they could make more money offering "family entertainment" and ended the touring burlesque acts. One of the large-scale acts to take the Busby stage was a performance of *Ben Hur*, in which eight white horses pulling chariots raced on a special turntable. (Courtesy of Steve DeFrange, Krebs Heritage Museum.)

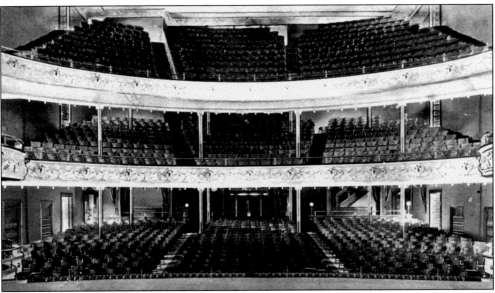

INTERIOR OF THE BUSBY THEATRE. Located as it was in a Southwest mining town, the Busby Theatre was completely out of proportion in regard to its size and elaborate design, but it quickly became the social focal point of the community. A. C. Estes was the general manager and as the booking agent brought some of the top national touring companies to the Busby Stage. (Courtesy of McHuston Booksellers.)

PORTRAIT OF CY PERKINS, 1915.
In between the big-name acts, the
Busby Theatre offered touring groups
such as that of Cy Perkins, part of
the so-called Orpheum Circuit that
offered comedy, music, plays, and
combinations of each. Having a
theater or opera house was the mark
of a progressive contemporary city,
and the Busby Theatre regularly filled
the 1,350-seat house. (Courtesy of
McHuston Booksellers.)

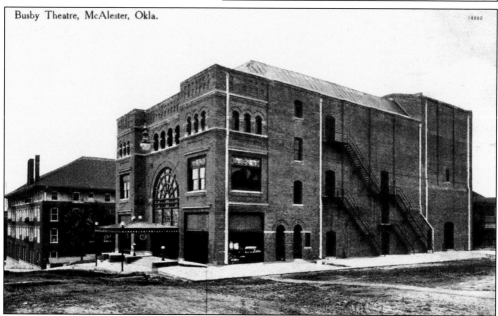

Busby Theatre, McAlester, Okla.

CORNER VIEW OF THE BUSBY THEATRE. After William Busby's death, the theater was never able to maintain its level of quality. Shown with the Busby Hotel in the background to the south, the theater and the hotel were sold for taxes at a 1914 sheriff's sale to the only bidder, the St. Louis mortgage holder. By 1916, movies were shown between the evenings of live entertainment. (Courtesy of McHuston Booksellers.)

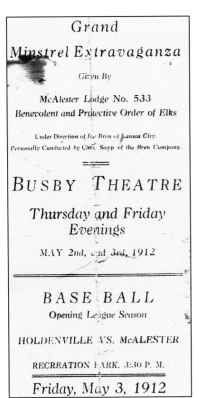

BUSBY THEATER PROGRAM, 1912. Before television, residents found ways to entertain themselves and their neighbors, and local programs were a staple, often directed by visiting artists, such as this Grand Minstrel Extravaganza, under the direction of Joe Bren of Kansas City. Most towns fielded baseball teams that were well attended by spectators, and the program mentions the season opener between McAlester and Holdenville at Recreation Park. (Courtesy of McHuston Booksellers.)

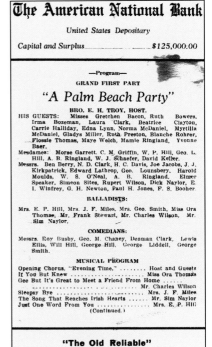

A PALM BEACH PARTY PROGRAM, 1912. The fete was hosted by Edward H. Troy, a 52-year-old Irish physician and local hospital administrator. Edward H. Troy's daughter Mary married William Berry McAlester, the son of J. J. McAlester. Also appearing in the program were Roy Busby, George M. Cheney, Denman Clark, and Dr. Thomas S. Chapman, who delivered a speech titled "Chronological Amalgamation of the Bosphorous." (Courtesy of McHuston Booksellers.)

A 1910 LETTER TO MRS. DANIEL M. HAILEY.
Written from the Seelbach Hotel in Louisville,
this letter from Metropolitan Opera singer
Vera Courtenay demonstrates the charismatic
nature of the mining town society. Courtenay
sang soprano during the 1910 opera season,
and in her letter describes her performances
with tenor Enrico Caruso and her intention
to catch a train between performances to visit
the Hailey family at McAlester. (Courtesy of
McHuston Booksellers.)

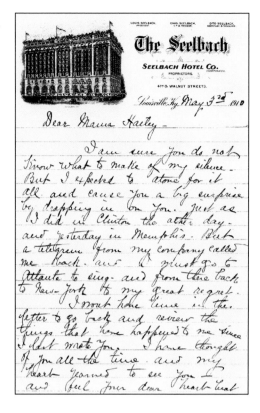

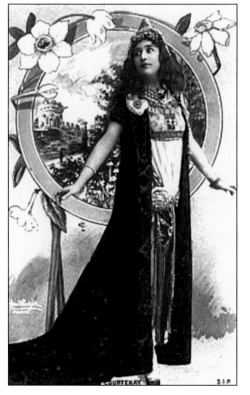

OPERA CARD OF VERA COURTENAY. Details of
her Busby performance are unclear, but soprano
Vera Courtenay had a continuing friendship
with the Hailey family of McAlester. Courtenay
studied in Paris and was the first to perform
Manon in French at Berlin. She sang in four
concert performances with the New York
Metropolitan Opera for the 1909–1910 season
and appeared as Musetta on tour with Enrico
Caruso. (Courtesy of www.historicopera.com.)

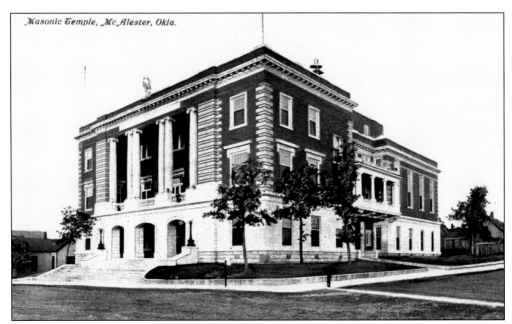

MASONIC TEMPLE AT MCALESTER. When William Busby arrived at McAlester, Masons met at the building that later became the Elk's lodge on Washington Avenue. In 1904, Busby took an option on property at the highest point in the community, envisioning a building that would be the largest in the territories and grander than the temple at Little Rock, at the time the finest west of the Mississippi. (Courtesy of McHuston Booksellers.)

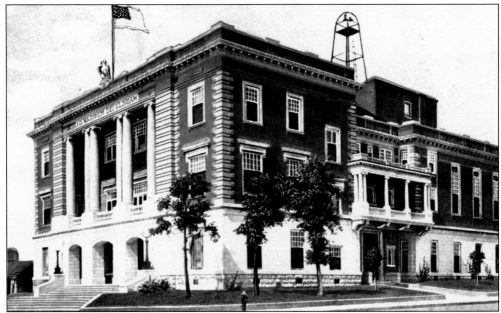

MASONIC TEMPLE POSTCARD. Officials dedicated the Masonic temple on April 22, 1907, and the event drew dignitaries from all over the country. A critical part of the temple's pipe organ was still awaiting installation, and Busby tracked it to an eastern rail siding. He managed to have it rushed to Kansas City and dispatched a special train to retrieve it in time for the dedication. (Courtesy of McHuston Booksellers.)

Five

BEYOND STATEHOOD

The presence of the two railway lines created a transportation hub that encouraged commerce of all types, and even before the Twin Territories entered into the union as the state of Oklahoma, merchants engaged in commerce nationwide. Naturally the county's high-quality coal had ready markets all across the United States, with more than 200 railcars shipped out daily.

There were two brick factories by 1900, an ice plant, a cotton compress, a laundry, four wholesale grocery distributors, an iron foundry and machine shop, and even a macaroni factory. Joseph and John Fassino operated McAlester Macaroni at 123 South Third Street and became the first international shipper from Pittsburg County, sending a railcar of macaroni to Cuba. It was so well received that Cubans offered to buy all Fassino could produce, but he declined, having a ready local market.

Under federal jurisdiction, it took an Act of Congress to combine North and South McAlester. When approval came, the unified community was known simply as McAlester, and a July 1, 1907, post office designation made the change visibly official. At statehood, county lines were redrawn and Krebs residents campaigned mightily to be declared the county seat but could not overcome the greater number of votes from the much larger community at McAlester.

Astoundingly, at a time when women were not allowed to vote, social reformer Kate Barnard in 1907 became the first woman in the United States to be elected to statewide office and served two terms as commissioner of charities and corrections. There were no prisons in Oklahoma at the time, and after Barnard's plan to build a prison at McAlester passed, inmates were housed at the federal jail until the construction was completed.

Growth continued at a rapid pace in Pittsburg County, and shortly before his death in 1913, William Busby stated his optimistic expectations for the future, which would have McAlester as a continued rival to Oklahoma City as a population center. A shift to oil as an energy source diminished the demand for coal, and that, along with the effects of the Depression, eventually ended the boom.

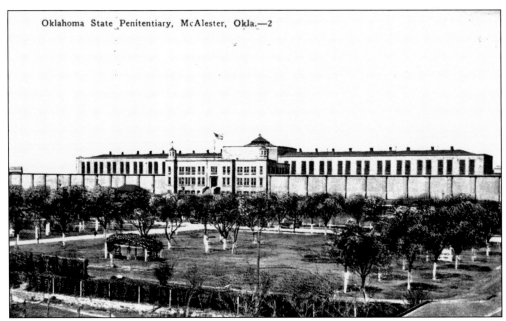

OKLAHOMA STATE PENITENTIARY AT MCALESTER. Before statehood, prisoners were shipped to Kansas to be housed at a rate of 25¢ per day. The new legislature appropriated over three-quarters of a million dollars to finance the maximum-security facility, and in 1908, inmates were brought back from Kansas as construction workers on the project. The west cell house and an administration building were the first completed. (Courtesy of McHuston Booksellers.)

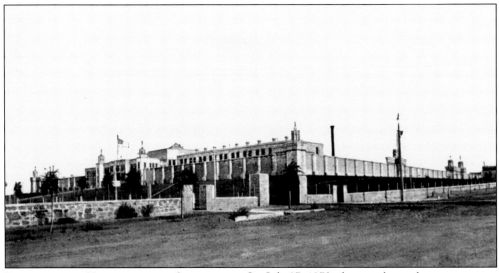

PENITENTIARY VIEW FROM THE SOUTHEAST. On July 27, 1973, the mostly costly prison riot in the history of the United States occurred at the maximum-security penitentiary, with damage estimated at $20 to $40 million. The newest wing of the prison was razed in 1976 when it was deemed irreparable. Signage at the edges of the city limits long proclaimed that "Hitchhikers May be Escaping Inmates." (Courtesy of McHuston Booksellers.)

NOTICE TO WORK STREETS

No. 98 McAlester, Oklahoma, *June 8th* 190 8

To *Luther McKissick*

You are hereby notified to appear at the City Hall of McAlester, at 8 o'clock A. M., on the
15-th day of *June*, 190 8, for the purpose of working the streets,
avenues and alleys in the *1st* Ward, beginning on the above named date and working
four (4) days. You are further warned to bring a shovel with you. In lieu of working, you may
at or before that time pay the Street Commissioner $4.00.

C. E. Jackson Street Commissioner.

I certify that I served the above notice on the *8th* day of *June*, 190 8,
by delivering a true copy to said *Luther McKissick*, in McAlester, Oklahoma.

J. W. Kerr

NOTICE TO WORK STREETS, 1908. Before road working machinery, town residents were called upon to make the repairs necessary to keep the roads in passable condition. This notice was delivered to 28-year-old Luther McKissick, who lived in Second Ward with his wife, Hattie, with instructions to appear at 8:00 in the morning to work the streets, avenues, and alleyways for a four-day period. (Courtesy of McHuston Booksellers.)

No. 8 **$4.00**

RECEIPT FOR ROAD TAX

McAlester, Okla., JUN 9 - 1908 190

Received of *Luther McKissick* FOUR DOLLARS,
in payment of City Road Tax, in lieu of Four Days Work, for the year

190 8

Ward *1st*

C. E. Jackson

Street Commissioner.

ROAD TAX RECEIPT, 1908. Men were expected to repair the roadways and were "further warned" to bring a shovel. In lieu of four hot days smoothing out ruts, citizens could pay a $4 tax to hire someone else to work. At the time, Luther McKissick worked as a foreman at a local laundry and opted to pay the tax rather than lose days on the job. (Courtesy of McHuston Booksellers.)

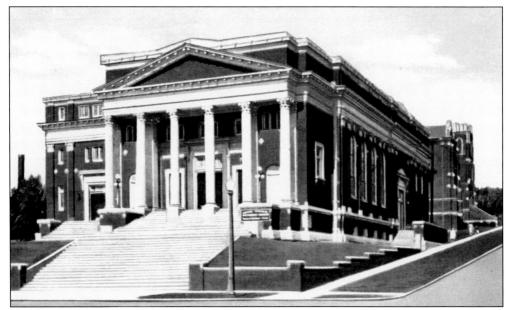

GRAND AVENUE METHODIST CHURCH. Among the impressive structures that were constructed on what was then called Grand Avenue, was the Methodist church, now officially located at 225 East Carl Albert Parkway and built long before the avenue had a dividing center median. In the first city directory, South McAlester had five Methodist congregations, some dating from the early 1890s. (Courtesy of McHuston Booksellers.)

FIRST CHRISTIAN CHURCH POSTCARD. Organized before 1900 and originally in a log cabin that was erected at its present site, this image depicts the third building to house the congregation, constructed in 1925. Rev. J. T. Hawkins was pastor in 1900 when the church had a membership of 300. Pastor W. Mark Sexton was the founder of the Order of the Rainbow for Girls, an international service organization. (Courtesy of McHuston Booksellers.)

TROOPS ON GRAND AVENUE. This World War I–era photograph shows troops lined and facing north along what was then a brick-paved Grand Avenue. Visible behind the troops are the Dow Coal Company Building and the S. H. Kress Company, a variety store. At the extreme right is the original tree, still standing in the street, although surrounded by a low barrier. (Courtesy of Lesley Brooks.)

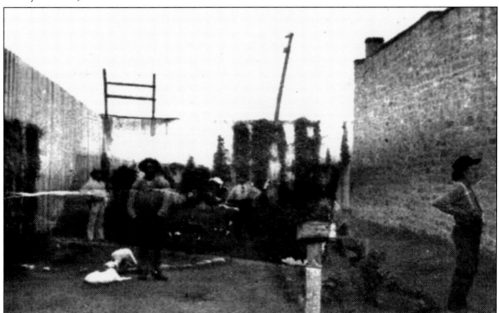

PRISONERS IN THE STOCKADE. After statehood, Oklahoma was forced to reclaim the prisoners housed by the State of Kansas, and they were housed at a jail near the federal building until the state prison construction was completed. During Indian Territory days, nontribal offenders were detained in a federal stockade, little more than an open-air pen, until they were taken to the United States court at Fort Smith. (Courtesy of Steve DeFrange.)

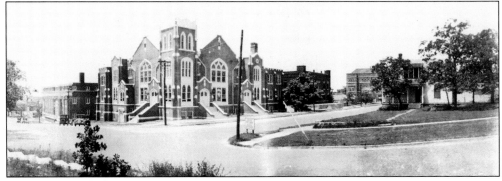

FIRST PRESBYTERIAN CHURCH VIEW. Looking to the southwest at the intersection of Third Street and Washington Avenue, this is an early-day wide-angle photograph that includes the First Presbyterian Church, founded in 1912. The building shown was completed in 1927. Just to the right of the gap in the line of buildings is the Busby Theatre, on the southwest corner of Second Street and Washington Avenue. (Courtesy of Lesley Brooks.)

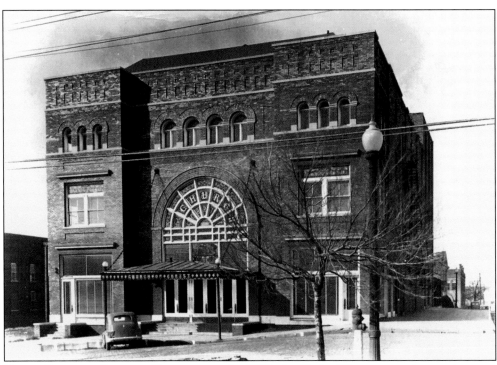

BUSBY THEATRE CHURCH CONVERSION. In 1929, the Busby Theatre was shuttered except for the use as an occasional meeting place, and in 1932, the building was purchased by the Church of Christ, which replaced the identifying glass lettering above the entryway as part of a several-thousand-dollar interior remodeling. Regular meetings by the congregation moved into the former Busby in 1935 and continued there until 1979. (Courtesy of Lesley Brooks.)

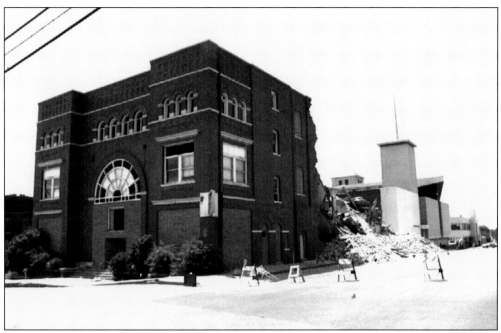

DEMOLITION OF THE BUSBY THEATRE. Partly due to absentee ownership, the Busby Theatre never had the opportunity for regular maintenance, and by the time the building was purchased by the First Baptist Church, the interior structure was well rotted and considered dangerous. Rather than undertake what would be an enormous financial expenditure, a decision was made to raze the building to use the property for other purposes. (Courtesy of Lesley Brooks.)

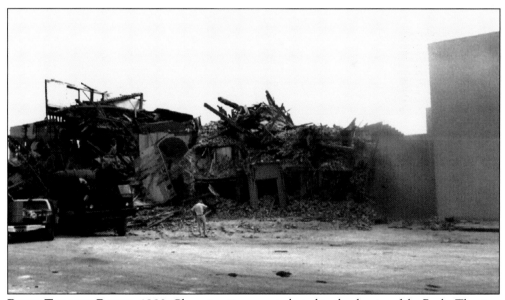

BUSBY THEATRE RAZED, 1983. Changing times contributed to the demise of the Busby Theatre, including the introduction and popularity of motion pictures. A theater on Choctaw Avenue was already showing silent two-reel films when the Busby opened, and touring live shows could not compete with the stream of improving films. The stained-glass windows over the front entryway are all that were saved from the one-time showplace. (Courtesy of Lesley Brooks.)

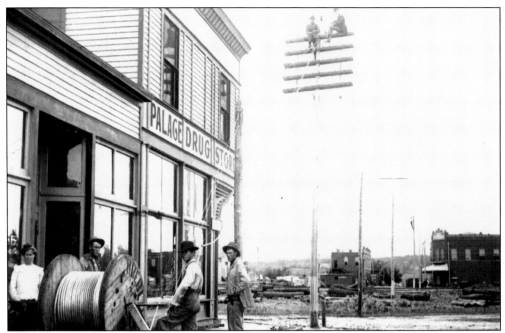

WIRING THE COUNTY. Workers can be seen perched atop a telephone pole crossbar in this undated photograph that demonstrates how aesthetics were secondary to practicality, and the lines were strung directly in front of the buildings. In August 1904, William Busby purchased the South McAlester-Eufaula Telephone Company and replaced most of the poles and lines, along with some 700 telephones that required operator assistance. (Courtesy of Lesley Brooks.)

PICKING OKLAHOMA COTTON. This World War I–era postcard depicts the Oklahoma cotton fields, many of which were worked by tenant sharecroppers. Following the Civil War, an influx of migrant families hoped to find a new start in the territories, and many worked for landowners as tenant farmers. A cotton compress was in operation in Pittsburg County before 1900. (Courtesy of McHuston Booksellers.)

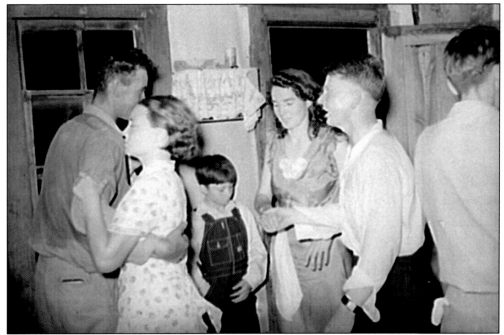

DANCE AT A SHARECROPPER'S HOME. It was never all work, even during the Depression era. This 1939 photograph by Russell Lee of the Farm Security Administration shows the interior of a rural Pittsburg County home serving as a dance hall for tenant farmer couples. Much of southeastern Oklahoma suffered during the Depression, and many families migrated to Pittsburg County hoping for better economic times. (Courtesy of Library of Congress.)

SQUARE DANCE MUSICIANS, 1939. Considered a post–Civil War method of employing former slaves, nearly two thirds of the 20th-century sharecroppers were white. These Pittsburg County sharecroppers were typical of the arrangement that allowed tenants a plot of land to cultivate in exchange for a share of the harvest. Most lived in continuing poverty and had to create their own recreation, including music and dancing. (Courtesy of Library of Congress.)

UNION IRON WORKS STATIONARY. Previous to his involvement in the Tobucksy County mines, William Busby served as president of South McAlester Union Iron Works and Machine Shop. The company supplied pumps and fans for use in the area mines. This letter was received at Lutie, a mining camp closer to Wilburton but part of the Hailey-Ola mining industry, where 15 men died in a 1930 accident. (Courtesy of McHuston Booksellers.)

LETTER TO LUTIE INDIAN TERRITORY. Designations for the individual tribal nations are uncommon, but this registered letter to lumber manufacturer Joseph H. Francis was addressed to the community of Lutie in Choctaw Nation and features a 1905 postmark. Several major mining accidents occurred at Lutie, including a January 1929 explosion at Degnan-McConnell's Lutie 21 Mine in which 91 men died. (Courtesy of McHuston Booksellers.)

BOATING ON DOW LAKE. This prestatehood image features two couples in their top hats and bonnets at the popular Dow Lake recreational area. The photograph is by Peter W. Marcellus, who ran the Marcellus Art Studio out of his home at 616 East Grand Avenue in South McAlester. Dow is an unincorporated community on Highway 270 between McAlester and Haileyville. (Courtesy of McHuston Booksellers.)

HIGGINS, OKLAHOMA, POSTCARD. Located near Pusley's Station on the Butterfield Stage Route, the unincorporated community of Higgins was named for early jurist R. W. Higgins and was formerly called Caminet. The community is some six miles from Hartshorne and fell within the boundaries of Latimer County when lines were redrawn at statehood. A post office was established, and the name changed to Higgins in 1903. (Courtesy of McHuston Booksellers.)

DOW LAKE POSTCARD, 1910. This postcard indicates a McAlester location, but this image was taken near Dow, Oklahoma, which is located some 10 miles southeast of McAlester and some three miles northwest of Haileyville. In the early 1900s, Dow Lake Park was a very popular recreation spot for picnicking, boating, and swimming. A dock visible in the background is featured in several other postcards. (Courtesy of McHuston Booksellers.)

YOUNG GIRL AT DOW LAKE. This postcard features a young girl balanced on a log at the shore's edge at Dow Lake and was postmarked October 1911. The message on the back includes the note that "We are way out here where they raise lots of cotton and we see many Indians." Across the lake from the dock area shown was a popular dance hall. (Courtesy of McHuston Booksellers.)

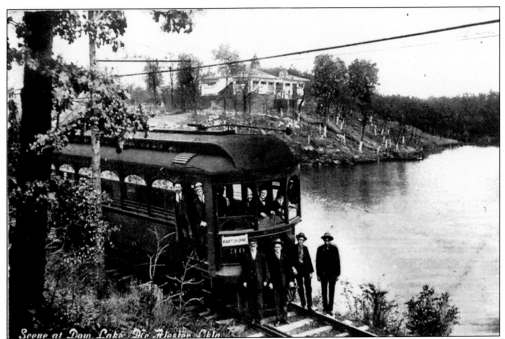

PITTSBURG COUNTY ELECTRIC TROLLEY AT DOW LAKE. Hundreds of people gathered during the day, and live bands entertained every weekend at Dow Lake, where the trolley ran regularly. The park featured a waterslide and several amusement park–type rides, a boat dock, and picnic areas. In the background is the Owl Club, a recreational dance hall at Dow Lake Park. (Courtesy of Steve DeFrange, Krebs Heritage Museum.)

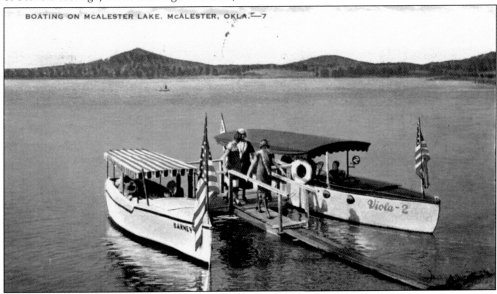

LAKE MCALESTER POSTCARD. The dock and canopy boats are very similar to those in the Dow Lake postcards, but the caption on this image indicates it is Lake McAlester. The photograph was taken previous to 1930 and features women in clothing typical of the 1920s. Water-related activities have always been popular in Pittsburg County, and the creation of Lake Eufaula added hundreds of miles of shoreline. (Courtesy of McHuston Booksellers.)

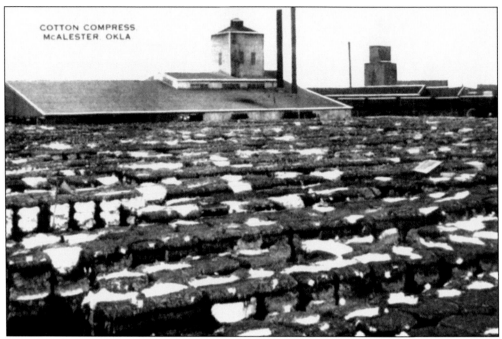

COTTON COMPRESS AT MCALESTER. Immigrant workers provided the labor and brought baskets of cotton from the fields to the cotton gin, a term derived as a shortened form of cotton engine. Cotton was raked across a tray, and resulting lint fell through the floor for storage until a quantity was collected for baling. That operation took place in an area separated from the cotton gin. (Courtesy of Steve DeFrange.)

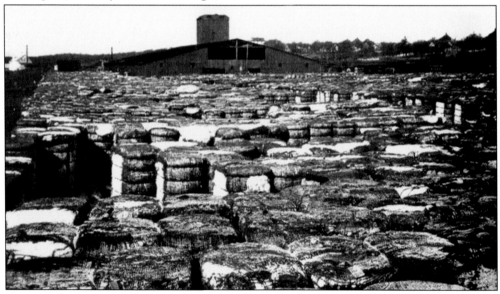

COTTON BALES AT MCALESTER COMPRESS. From the lint room, baskets of cotton lint were carried to the compress, a large wooden screw with a plunger that pressed down on the cotton inside a baling box. Mules harnessed to sweeps walked in circles to raise and lower the screw. Once tied with rope, the resulting bundles weighed in excess of 400 pounds. (Courtesy of Steve DeFrange, Krebs Heritage Museum.)

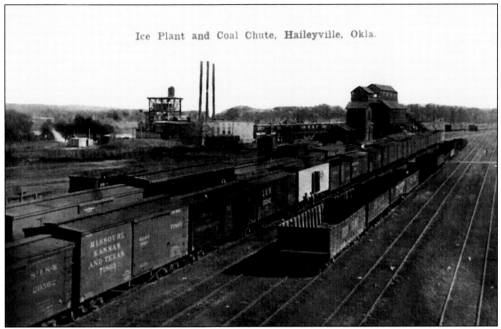

Ice Plant and Coal Chute, Haileyville, Okla.

HAILEYVILLE KATY RAIL SPUR. The availability of the railway lines in all directions created a shipping hub for a great many Pittsburg County industries. At Haileyville, the rail siding accommodated coal chutes and the ice plant production. Armour Packing Company began using refrigerated railcars before 1910 to allow nationwide shipping of fresh meat products, requiring a steady supply of ice. (Courtesy of Steve DeFrange, Krebs Heritage Museum.)

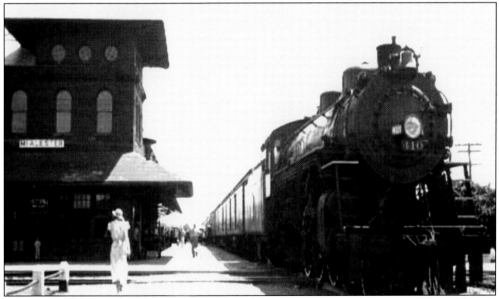

KATY FLYER AT UNION STATION. The two railways crossed near Choctaw Avenue and Main Street in South McAlester, the location of the union railroad station, which was completed in July 1905. In actuality, the McAlester streets were determined by the rail crossing, which spurred movement of the businesses south from the original McAlester location. The station was located at the southeast quadrant of the crossing. (Courtesy of Steve DeFrange.)

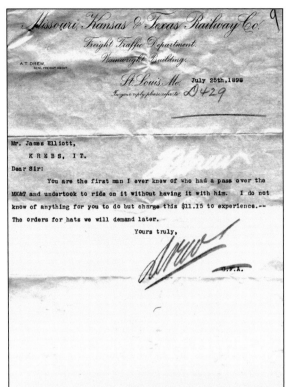

LETTER TO JAMES ELLIOTT AT KREBS. In 1898, James Elliott owned a rail pass for the Missouri, Kansas and Texas Railway Company but failed to take it on a trip from Pittsburg County to Kansas City. This letter, from A. T. Drew, the general freight agent in St. Louis, declines to issue a voucher for the $11.15 fare and suggests that Elliott charge it "to experience." (Courtesy of McHuston Booksellers.)

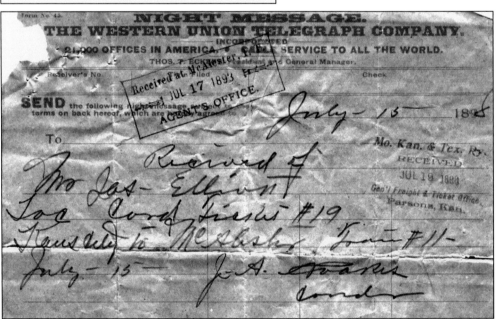

NIGHT MESSAGE FROM WESTERN UNION. Telegrams were a common method of communication in the early 20th century, and a night message was a lower-rate telegram that was sent during the night and delivered the next morning for a 25¢ minimum. This document was a receipt and conditional ticket issued by the train conductor for James Elliott of Krebs, who failed to take his pass. (Courtesy of McHuston Booksellers.)

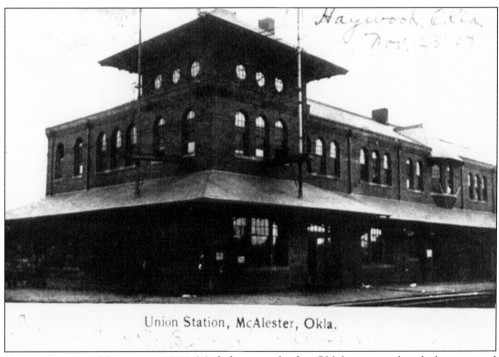

KATY RAILROAD TICKET RECEIPT. James Elliott came to Indian Territory about 1884 and worked for the Osage Trading Company but by 1905 had his own store with William Flesher and Frank Dale in Krebs. This receipt is for a first-class rail ticket from Kansas City to McAlester. Elliott wired to have his rail pass sent to him by train, but it failed to arrive in time. (Courtesy of McHuston Booksellers.)

UNION STATION, NOVEMBER 1907. Mailed one week after Oklahoma statehood, this postcard features the union depot at McAlester that opened in 1905, featuring a 24-hour lunch counter and waiting rooms with space enough to handle the baggage and passengers associated with 18 passenger trains daily. The Harvey House restaurant employed the uniformed "Harvey Girls" as waitresses who lived upstairs in a dormitory above the depot. (Courtesy of Steve DeFrange.)

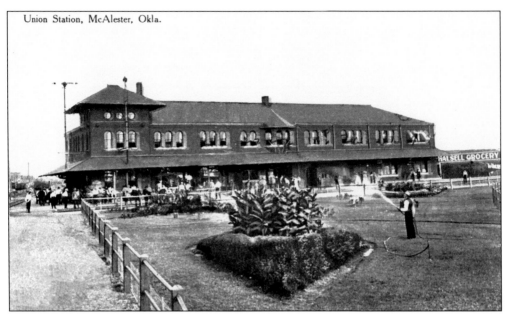

Union Station, McAlester, Okla.

UNION STATION POSTCARD. Dining at the union depot was impressive enough to draw customers from up and down the line who caught trains to eat at the McAlester Harvey House. In the background to the right is the Hale-Halsell Grocery Building at 214 South Main Street. Tom Hale bought the Townsend Wholesale Grocery at that location and moved his Durant business north because of the railroad. (Courtesy of McHuston Booksellers.)

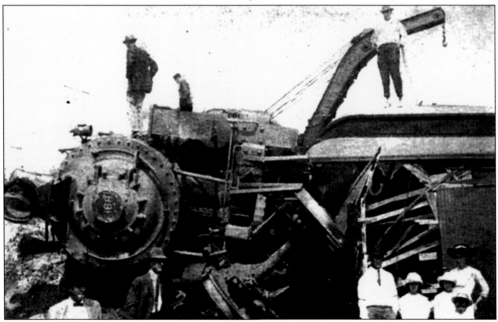

KATY PASSENGER TRAIN WRECK. Engine 368 was pulling a Missouri, Kansas and Texas Railway passenger train in 1912 when it hit several mules standing on the tracks two miles south of McAlester. One of the mules was thrown against a switch-handle, which opened the switch and sent the train onto a short spur for coal loading. A woman passenger was killed in the resulting derailment. (Courtesy of Steve DeFrange.)

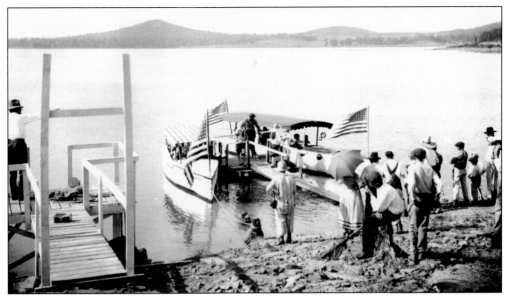

BOATING AT LAKE MCALESTER. This image of Lake McAlester shows additional docks and part of the crowd gathered for the canopy-top boat rides. Lake McAlester is located northwest of the city off Highway 113. The availability of lakes and streams has long made water-related recreation popular in Pittsburg County, and the dedication of Lake Eufaula by Pres. Lyndon Johnson in 1964 brought additional facilities. (Courtesy of McAlester Public Library.)

CROWD AT LAKE MCALESTER. Hundreds of residents line the banks to watch the boats on Lake McAlester in this undated photograph. There are no visible concession areas, picnic baskets or blankets, drinks, or swimwear, but the crowd is intently watching the activity. The dock extending into the lake is nearly at water level from the weight of the gathered men. (Courtesy of McAlester Library.)

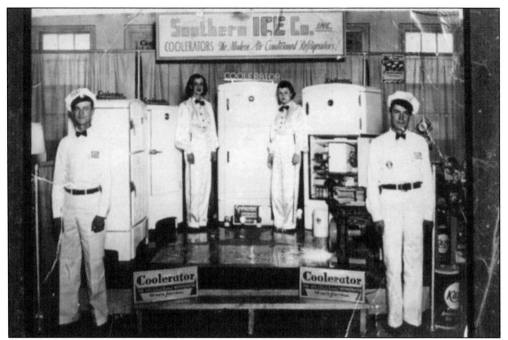

SOUTHERN ICE COOLERATORS. The original Coolerator was a lined box that could handle a block of ice and keep the milk and butter chilled even during the hot summer months. By 1935, the Coolerator was advertised as an "air-conditioned refrigerator" that sold for $72.50. That was the same year that nylon was patented and was first used to make a nylon-bristled toothbrush. (Courtesy of Steve DeFrange.)

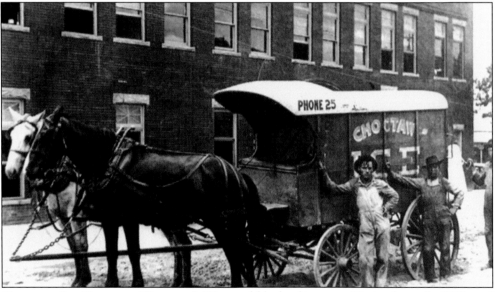

CHOCTAW ICE DELIVERY WAGON. A 25-pound block of ice cost 15¢ in the early 1900s and lasted from one to two days depending on the weather. A small drain directed the melted ice water into a pan underneath the icebox, which had to be emptied frequently to avoid spills. The mass-production of electric refrigerators beginning in 1913 contributed to the gradual demise of the icebox. (Courtesy of Steve DeFrange.)

Six

PEOPLE, PLACES, AND EVENTS

As it is with any place where people are gathered over time, Pittsburg County has had its share of delegates and events that have gathered national attention. If community leaders seek attention for their locale, it is always hoped to be favorable.

Six miles northeast of McAlester is a lake community named Flowery Mound almost universally called Bugtussle, the home of Oklahoma's highest-ranking political figure, Carl Bert Albert, a United States Congressman who served as speaker of the House of Representatives from 1971 to 1977. When Vice Pres. Spiro Agnew resigned his office in 1973 and for a six-week period until the swearing-in of Vice Pres. Gerald Ford, Albert would have assumed the presidency had Richard Nixon resigned or become unable to fulfill the duties of the office. Albert was in the unique position of being a member of an opposing party, heading the only political body with the power to remove a sitting president, and could have effectively maneuvered himself into the nation's highest office. Albert ended all speculation by declaring that should the office be vacated, he would serve only as acting president until a Republican vice president could be confirmed. Following his retirement in 1977, Albert could be seen regularly around Pittsburg County, where a bust in his honor was erected at the federal building.

The best left-handed pitcher in major-league baseball history retired to Oklahoma and his Pittsburg County ranch near Hartshorne. Warren Spahn won 20 games in 13 different seasons, played most of his 21 years for the Braves at Boston and Milwaukee, and was elected to the hall of fame in 1977. He was well known at the Hartshorne Post Office, where baseball devotees sent fan mail by the bagful seeking an autograph. Warren Spahn later moved to Broken Arrow, Oklahoma, where he died on November 24, 2003, but he was buried at Elmwood Cemetery in Hartshorne, and the family retains the Pittsburg County ranch.

Two-term Oklahoma governor George Nigh was born at McAlester in 1927 and was a McAlester High School teacher when he was first elected to the state legislature.

YOUNG BARKERS ADVERTISING A MOVIE. The earliest theaters were converted halls or churches, with the first true theater built at Los Angeles in 1903. By the time the Busby Theater was completed in 1905, McAlester already had a movie theater on Choctaw Avenue. The young men are using a megaphone to advertise a longer movie, a two-reeler, which ran some 10 minutes per reel. (Courtesy of Lesley Brooks.)

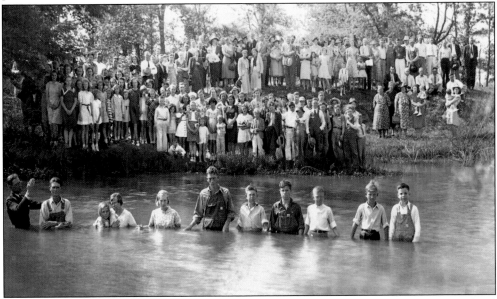

PITTSBURG COUNTY GROUP BAPTISM. A group enters the water to be baptized in this undated image that shows a supporting congregation gathered at the water's edge. Dating from its earliest settlement, the county has had a wide variety of faiths represented with regular congregations, and the presence of traveling preachers and tent revivals were common. (Courtesy of McAlester Public Library.)

EARLY WOODEN FIRST BAPTIST CHURCH. One of the earliest churches in the county was the First Baptist, founded by Civil War veteran William A. Tredwell and 10 others in 1892. This wooden building was located at First Street and Grand Avenue, where the congregation met until a larger structure was built at First Street and Washington Avenue. Tredwell served for many years as the McAlester city assessor. (Courtesy of McAlester Public Library.)

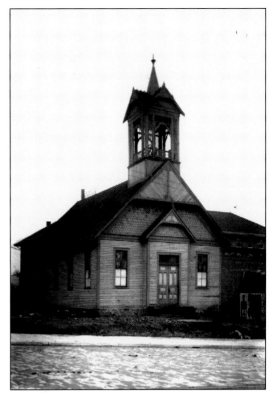

McALESTER HIGH SCHOOL FOOTBALL, 1916. The appearance of the equipment may have changed, but the passion for sports and football in particular has remained the same since the earliest days of the school system. Public schools began at McAlester in 1900 following the incorporation as towns in 1899. (Courtesy of McAlester Public Library.)

MCALESTER FIREMEN, 1926. From left to right are (first row) Jesse Payne, Jesse Holbrook, Fred Hawkins, Chief Miller, Bob Scoggins, George Burk, and Ben ?; (second row) Earl Utterback, M. J. Dean, Jack Granthum, Aduphus Burt, Clarence Price, and Otis Price; (third row) Homer Casey, Ben Branum, Leonard England, Ed Mitchell, and Ralph Grossline. (Courtesy of McAlester Public Library.)

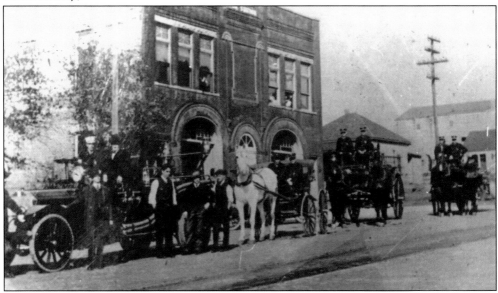

CITY HALL AND FIRE DEPARTMENT, 1915. It was shortly after the introduction of automotive fire engines that McAlester acquired its first model for use alongside the horse-drawn wagons. The equipment faced some intense trials, as a number of significant fires occurred before 1920, including the Busby Hotel and the recently completed high school building. (Courtesy of McAlester Public Library.)

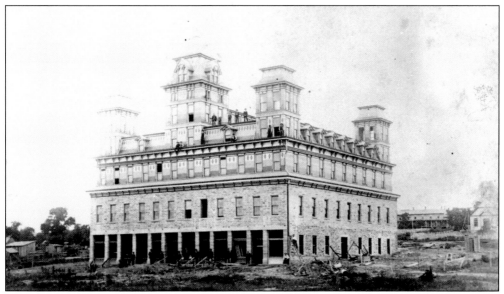

KALI-INLA BUILDING CONSTRUCTION ON CHOCTAW AVENUE. The original construction effort at South McAlester came from the railroad, and Edwin Chadick envisioned his hotel as a showplace for his company and visiting dignitaries. He offered free rooms for lawyers and judges if Congress would locate a district court at McAlester. Unfortunately, the lawsuits began before the top floors were even completed, and they were later removed as hazards. (Courtesy of Lesley Brooks.)

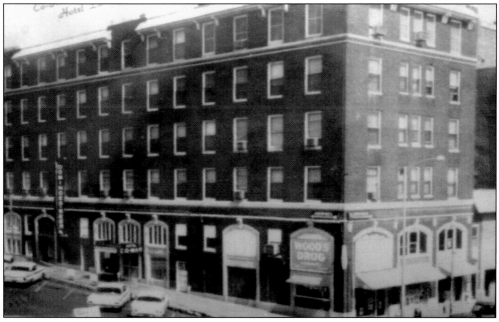

CO-MAR HOTEL AT MCALESTER. The original Kali-Inla had three native stone floors and two elaborate floors above made from wood. When the railroad went into receivership, the building was sold and remodeled with the upper two floors removed. Further renovations created spaces for businesses at street level and a hotel above, which operated under a series of names, the last being the Co-Mar Hotel. (Courtesy of Lesley Brooks.)

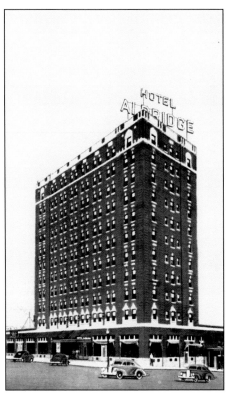

HOTEL ALDRIDGE POSTCARD. Designed by architects Harmon and Mattison and completed in 1930, the Hotel Aldridge in 1995 was entered on the National Register of Historic Places. Later residents may not recall the street-front businesses that were part of the hotel site. The hotel fell into decline in later years but remains as a presence on Carl Albert Parkway in McAlester. (Courtesy of McHuston Booksellers.)

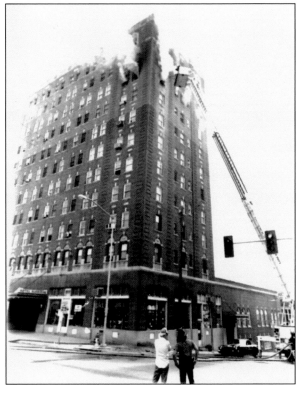

FIRE AT THE HOTEL ALDRIDGE. During the 1930s, the Aldridge Hotel Chain had operations across the United States, several of which suffered damage by fire, including hotels at McAlester and nearby Ada. Efforts to battle the blaze were hampered by the height of the building and the inability to reach the topmost floor. (Courtesy of Lesley Brooks.)

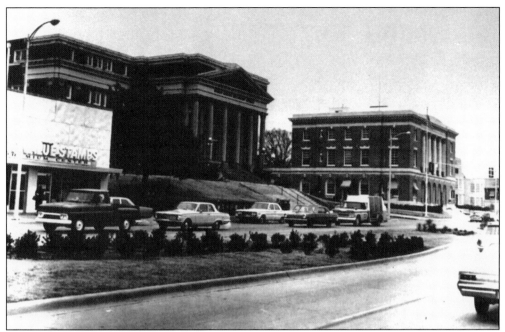

CARL ALBERT PARKWAY, 1968. Grand Avenue was renamed Carl Albert Parkway to honor the United States Congressman from Pittsburg County. A center median was constructed to divide the lanes of traffic. The Grand Avenue Methodist Church and the federal building are among the earliest structures to line the parkway. (Courtesy of Lesley Brooks.)

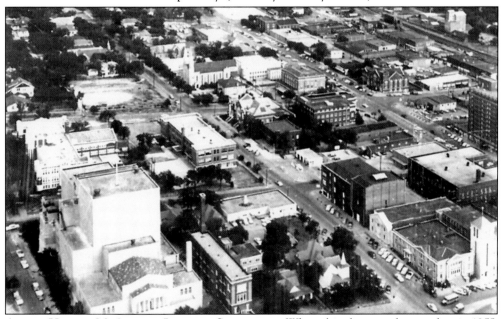

AERIAL VIEW OF MCALESTER LOOKING SOUTHEAST. When this photograph was taken in 1955, the streets in the downtown area had nearly completely filled with business and office buildings. The Masonic temple is visible in the lower left, and at the far right edge, the taller building is the Hotel Aldridge. McAlester High School and the Junior High are the two buildings behind the Masonic temple. (Courtesy of Lesley Brooks.)

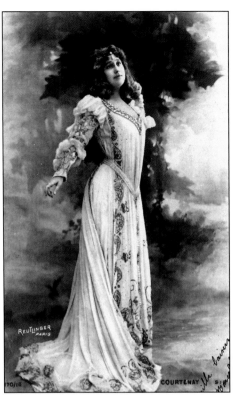

SOPRANO VERA COURTENAY OPERA CARD. Appearing on the European continent and in the small mining town of McAlester, Indian Territory, was Vera Courtenay, a Paris-trained American soprano. This opera postcard was published in Paris and was postmarked in 1904. Courtenay made several trips to Pittsburg County and corresponded with the family of Dr. Daniel Hailey. (Courtesy of www.historicopera.com.)

SIGNATURE OF VERA COURTENAY. In a letter written on May 3, 1910, while waiting for a train, soprano Vera Courtenay wrote to Helen Hailey, wife of Dr. Daniel Hailey, for whom Haileyville is named. Courtenay wrote that she had intended an unannounced visit by train but was unexpectedly called to perform in Atlanta, which ended her "little surprise party" for the Hailey family. (Courtesy of McHuston Booksellers.)

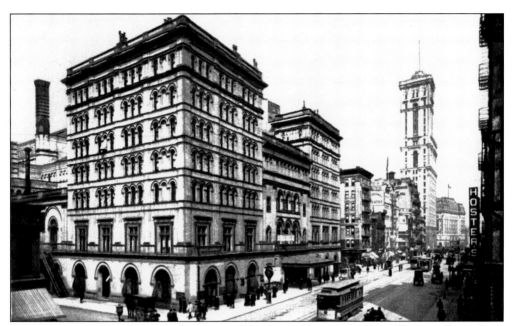

METROPOLITAN OPERA HOUSE POSTCARD. Visible on the streets of New York are the trolleys, cars, and horse-drawn carriages in front of the opera house where Vera Courtenay was the featured soprano during the 1910 season. Numerous acts that performed along these same streets made appearances in Indian Territory at the Busby. (Courtesy of McHuston Booksellers.)

MAUD ADAMS AS PETER PAN. In her best-known role, Maud Adams claimed to have played the part of the boy who "never grew up" some 1,500 times between 1905 and 1915. An October 8, 1912, show at the Busby featured Maud Adams, who was the first in a long line of actresses to play the part on and off Broadway. (Courtesy of Library of Congress.)

HANDMADE CHRISTMAS CARD, C. 1930. Although not as readily available as they became in later years, Christmas and holiday cards came into fashion in the 19th century. During the 1920s, with the popularity of the postcard, Christmas cards followed suit, but by 1930 the cards were usually enclosed in an envelope. (Courtesy of McHuston Booksellers.)

CHRISTMAS CARD COLLECTION. This assortment of hand-lettered holiday cards was mailed to a Pittsburg County resident over a period of years extending before and after 1930. The artist, Mary Estella Hammack, was a member of the 1924 graduating class at Flat River Junior College, the third public junior college in Missouri, now Mineral Area College in Park Hills, Missouri. (Courtesy of McHuston Booksellers.)

CHECK DRAWN ON SOUTH MCALESTER INDIAN TERRITORY. The First National Bank of McAlester was established in 1896 at South McAlester. The bank was originally located at 116 East Choctaw Avenue, and about the time this check was written, its president was F. S. Genung, W. J. Wade served as vice president, and cashiers were E. T. Bradley and Ben Mills. (Courtesy of McHuston Booksellers.)

COUNTER CHECK FROM FIRST NATIONAL BANK. If nothing else, this check shows the changes that have occurred in banking since the mid-20th century. The check was written in pencil to Central Drug on a bank check printed by the First National Bank, with the word *First* marked out and an identifier added. There is no account number, no routing number, and no computerized check number. (Courtesy of McHuston Booksellers.)

AIR MAIL COVER, 1952. It was an exciting trend when airmail began to replace letters carried around the country by train. The new method called for special airmail stamps, and an Air Mail Society collected commemorative envelopes with stamps that marked the initial runs. Air Mail route 80 commenced on May 1, 1952, and carried letters between Houston, Texas, and Tulsa, Oklahoma, with a stop in McAlester. (Courtesy of McHuston Booksellers.)

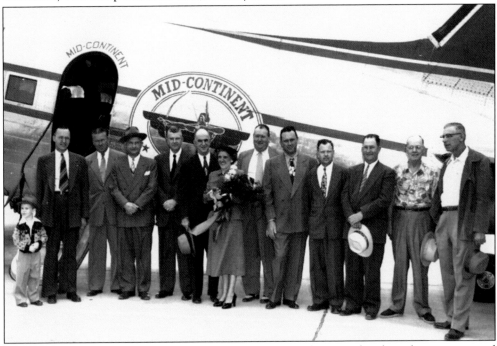

MID-CONTINENT AIRLINES SERVICE, 1952. The line of city and airline dignitaries stand beside a Mid-Continent Airlines plane at the inception of passenger flights from the McAlester Airport. The flights were described as "airline feeder service" schedules, which Mid-Continent and competing airlines provided through smaller cities in the Midwest, flying passengers to metropolitan flight hub connections. (Courtesy of Lesley Brooks.)

RUNWAY AT MCALESTER AIRPORT. Viewed from the southern approach, McAlester is seen to the north with the Masonic temple at the far left. In 1952, Mid-Continent Airlines merged with Braniff, contributing 23 Douglas DC-3s and four Convair 240s to the Braniff fleet. The feeder line served 35 cities at the time, from Minneapolis to Houston, through Tulsa and McAlester. (Courtesy of McHuston Booksellers.)

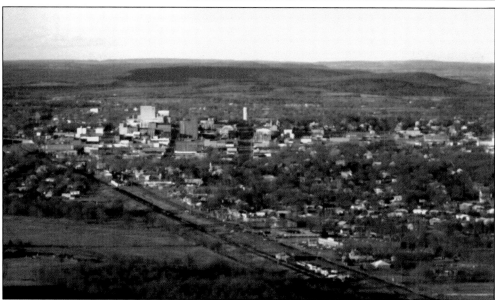

MCALESTER AERIAL SHOT FROM THE SOUTHWEST. Serving McAlester at the airmail service inauguration in 1952 was Mid-Continent Airlines, based in Kansas City and flying from a Tulsa hub. A 1951 flood ruined the Kansas City airport, and the relocated replacement was to be named Mid-Continent Airport, but Braniff acquired the regional airline in 1952. The new airport north of Kansas City was renamed Kansas City International. (Courtesy of McHuston Booksellers.)

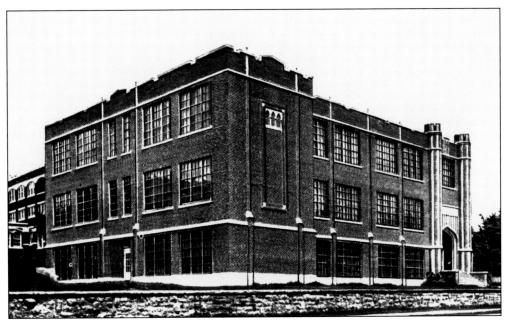

JUNIOR HIGH SCHOOL POSTCARD. The McAlester Junior High School building was constructed on Washington Avenue and in later years housed several high school–level classes as well. The addition of several new buildings in the late 20th century caused a near-total realignment of the upper-class students in Pittsburg County's largest school system. (Courtesy of McHuston Booksellers.)

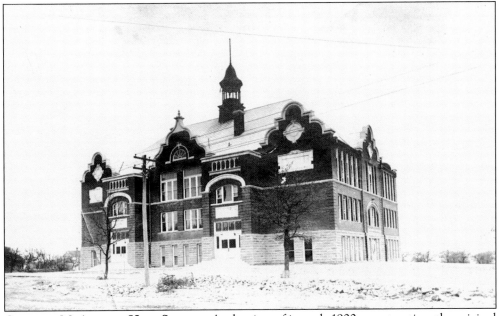

ORIGINAL MCALESTER HIGH SCHOOL. At the time of its early-1900s construction, the original McAlester High School was an impressive structure but suffered the fate of several of the earliest buildings. Located between Second and Third Streets on Adams Avenue, the building was gutted by fire after standing less than 20 years. This original photographic image is similar to a number of early postcards that survive. (Courtesy of Lesley Brooks.)

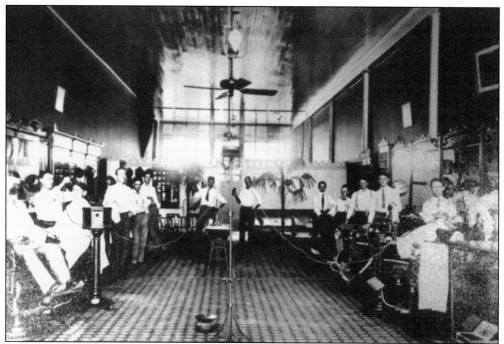

BUSBY HOTEL BARBERSHOP. In addition to a fine dining restaurant and a gift shop, the Busby Hotel had a large-scale barbershop, as shown in this 1905 photograph. After the loss of the hotel to fire, the lower-level business access was eliminated when the building was converted to house the Pittsburg County Courthouse. (Courtesy of Lesley Brooks.)

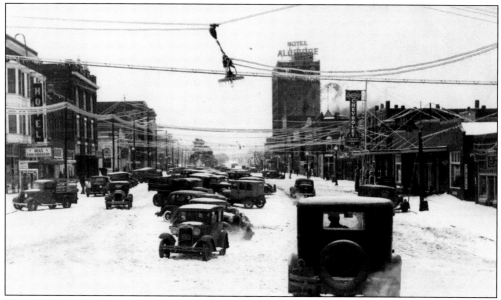

GRAND AVENUE SNOWSTORM, 1930s. Snowfall accumulation is moderate in the area, although there have been instances of heavy snow and ice. This photograph, taken after 1930, shows Grand Avenue looking west, with the Hotel Aldridge visible in the background. The Chevrolet dealer on the south side of the street had gas pumps at the curb, and across the street is a small hotel over Ben's Cash Grocery. (Courtesy of Lesley Brooks.)

A 1950s Ford in the Snow. Few instances of weather problems exist in Pittsburg County, although they have been recorded. A local adage professed the county to be immune to tornadoes because systems skipped over the valley, but a twister devastated McAlester during the early mining days, and a 1922 newspaper reported the deaths of 12 in the "foreign section" at Gowen, when a tornado struck there. (Courtesy of McHuston Booksellers.)

Trees in a 2000 Ice Storm. Pittsburg County is situated between the wintertime snowfalls of the northern counties and the warmer rain to the south, and freezing rain and accumulating ice create storms of a different sort. This 2000 image shows trees bending under the ice, but a January 2007 storm crippled the entire county, knocking out power and services for more than a week. (Courtesy of Lesley Brooks.)

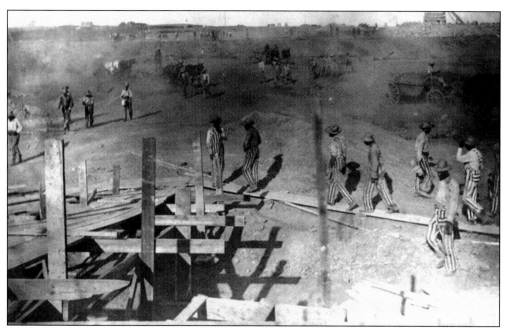

CONSTRUCTION OF THE OKLAHOMA STATE PENITENTIARY. After being admitted as a state, Oklahoma began construction of its maximum-security prison at McAlester. Prisoners were housed by the State of Kansas during territorial days but were returned to assist in the building of the penitentiary at the west edge of town. As shown, the prison inmates of the time wore striped clothing to identify them as prisoners. (Courtesy of Lesley Brooks.)

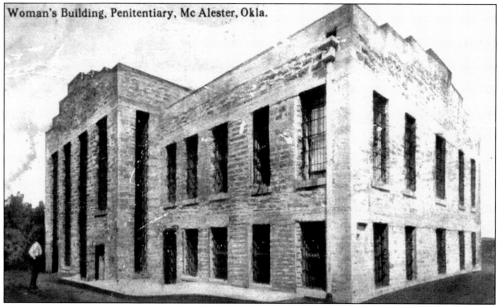

WOMEN'S PRISON UNIT AT THE STATE PRISON. Originally the women prisoners were housed above the administration offices, but this rock warehouse just east of the main prison was converted to hold the female population in 1911. In 1912, there were seven women in this building, which was replaced with a new structure in 1927. A significant percentage of early-day women inmates were incarcerated for adultery convictions. (Courtesy of Steve DeFrange.)

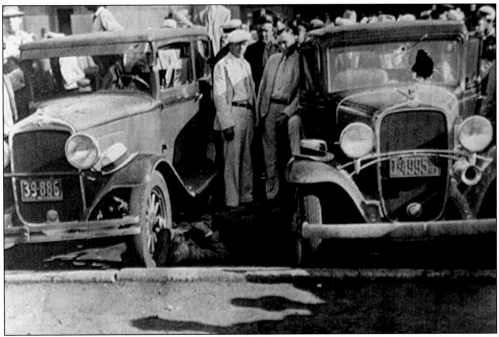

KANSAS CITY MASSACRE, 1933. McAlester police chief Otto Reed traveled with three Federal Bureau of Investigation agents in returning captured murderer Frank Nash to Kansas City, where an assault occurred. Three law enforcement officers were gunned down outside, and Chief Reed and Nash died in the car of gunshot wounds. (Courtesy of Lesley Brooks.)

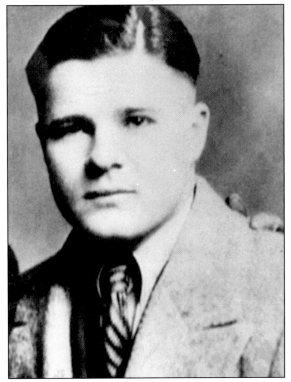

CHARLES "PRETTY BOY" FLOYD. A bank robber romanticized by the press, Charles "Pretty Boy" Floyd lived in the Cookson Hills north of Pittsburg County, near Sallisaw. He was accused in the June 17, 1933, Kansas City attack that led to the death of McAlester police chief Otto Reed, a charge Floyd vehemently denied. He died the next year in an Ohio shootout with police. (Courtesy of McHuston Booksellers.)

ELECTRIC CHAIR AT THE STATE PRISON.
In 1981, the State of Oklahoma changed its method of execution in death penalty cases to one incorporating a lethal dose of injected drugs, ending the practice of electrocution. The electric chair at the Oklahoma State Penitentiary was retired to a museum, and "Old Sparky," as it was often referred to, made occasional appearances at fairs and festivals. (Courtesy of Lesley Brooks.)

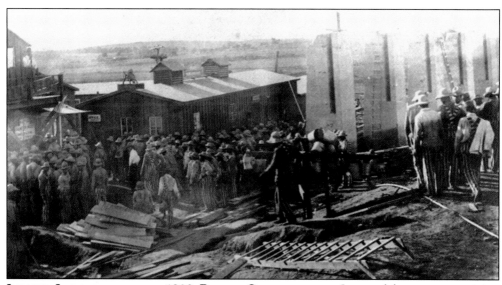

INMATE LABORERS DURING 1908 PRISON CONSTRUCTION. Inmate laborers are receiving instructions during the construction of the Oklahoma State Penitentiary, one of the first major projects undertaken by the new State of Oklahoma. The maximum-security prison housed the electric chair in a small enclave above which a sign declared "Crime Does Not Pay." (Courtesy of Lesley Brooks.)

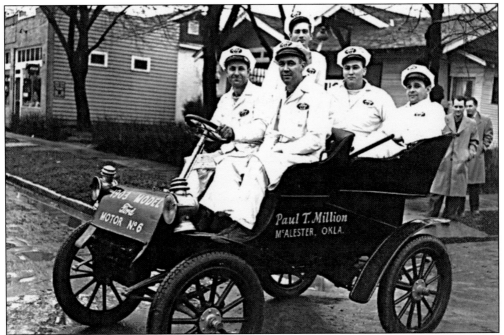

A 1949 PARADE ENTRY. Representing the Paul T. Million Ford dealership in a 1903 Model Ford are (from left to right) Dom Giacomo, Ray Strange, J. C. Williams, J. C. Whitehead, and Herman Lalli. Since its earliest days, Pittsburg County communities have paraded their businesses and social groups throughout the year, and the military associations of the area for many years provided support for an Armed Forces Day parade. (Courtesy of McAlester Public Library.)

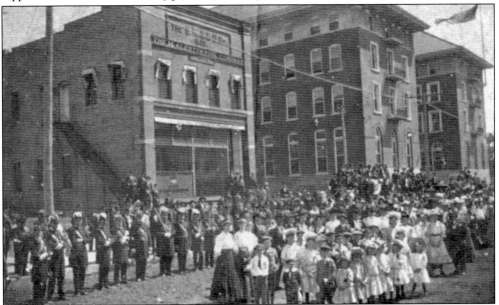

FOURTH OF JULY PARADE. Children line the street in this undated photograph of an Independence Day parade down Grand Avenue. Behind the parade to the left is the 1903 Great Western Coal and the Coke Building, shown housing the McAlester Fuel Company. To the right is the Busby Hotel. (Courtesy of Steve DeFrange.)

BASEBALL TEAM PARADE FLOAT. Championship baseball team members rode on the sponsor's float, and the logo is that of Reddy Kilowatt, a character created in 1926 by an executive of the Alabama Power Company. Electric power was still being extended to homes, and the character was seen as a way to ease consumer fear of the utility, which was adopted by power companies nationwide. (Courtesy of McAlester Public Library.)

A 1949 GOLDEN JUBILEE PARADE ON CHOCTAW. In period clothing and promenading in front of crowds lining the streets, these parade participants are moving east on Choctaw Avenue and are passing in front of Hunt's Department Store. Also visible are Florsheim Shoes, Pollocks, J.C. Penney, and Edward's Book Store. A painted sign on the side of the Co-Mar Hotel identifies its past as the Enloe Hotel. (Courtesy of Lesley Brooks.)

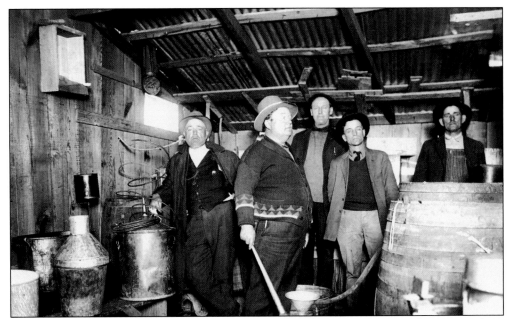

OPERATIONS AT AN OLD STILL. Just as brewing has a long history in America, the practice dates from the earliest days of Tobucksy County, the predecessor of Pittsburg County. The Choctaw Lighthorse police kept the peace but spent most of its time cracking down on the manufacture and sale of Choctaw beer. Choc beer, as it became known, evolved into recipes used in many residents' homes. (Courtesy of McAlester Public Library.)

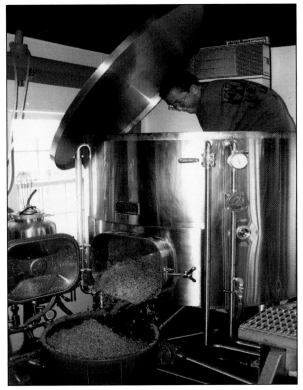

CLEANING THE MASH TUN AT PETE'S PLACE BREWERY. When voters changed the state liquor laws, one section allowed the creation of so-called microbreweries. Pete's Place in Krebs, which for years served a home-brewed version of Choc beer, now sells products from its brewery across the state and region. The stainless-steel vat is being cleared by Zachary Prichard, whose great-grandfather founded the Italian restaurant. (Courtesy of Joe Prichard.)

PRICHARD FAMILY AT PETE'S. In the kitchen of Pete's Place Restaurant are three generations of the Prichard family: (from left to right) Bill Prichard, who took over operations from his father in 1964; Joe Prichard, the current operator here in the arms of his father; and Pete Prichard, who operated out of his house before he officially opened the restaurant in 1925. (Courtesy of Joe Prichard.)

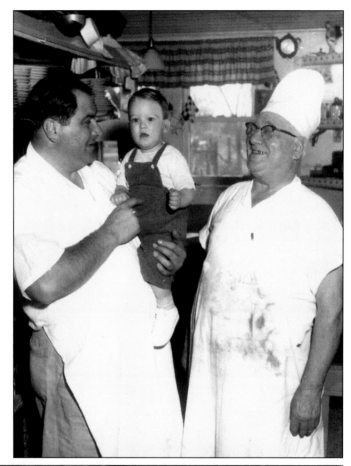

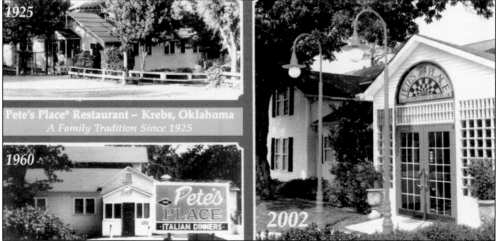

PETE'S PLACE POSTCARD. The restaurant was founded by Pietro Piegari, who traveled with his family from San Gregorio Magno, Italy, in 1903 and changed his name to Pete Prichard to work in the mines at age 11. During World War II, first-generation immigrants were not allowed to own weapons, and Pete managed to continue his restaurant operation without the use of knives. (Courtesy of Joe Prichard.)

PORTRAIT OF CARL BERT ALBERT. Oklahoma's highest-ranking political figure was born on May 10, 1908, at McAlester and was raised at the community called Bugtussle. A Rhodes scholar and University of Oklahoma graduate, Albert opened a law practice in Oklahoma City in 1935 and after the war was elected to Congress. He served until 1977 and retired to McAlester, where he died on February 4, 2000. (Courtesy of Library of Congress.)

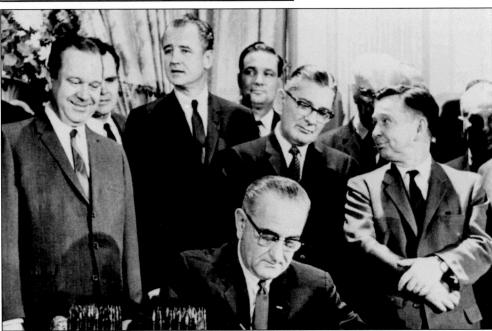

CARL ALBERT WITH PRES. LYNDON JOHNSON. Signing a landmark tax cut bill on February 26, 1964, Pres. Lyndon Johnson hoped to boost paychecks to the tune of $11.6 billion. Standing to the right of the seated president is Congressman Carl Albert of Oklahoma, who was elected House majority leader in 1961 and chaired the Democratic convention in Chicago in 1968. (Courtesy of Library of Congress.)

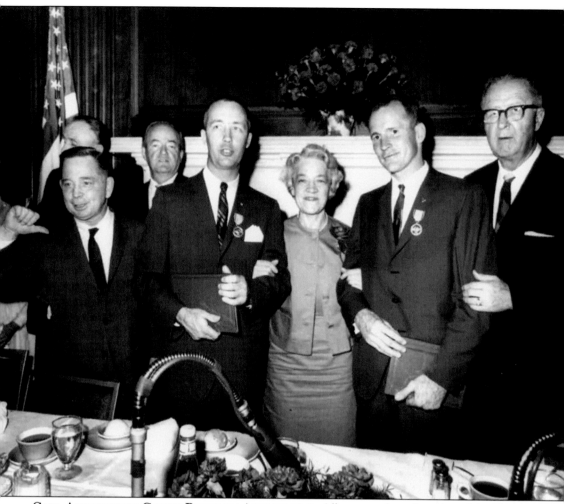

CARL ALBERT WITH GEMINI PROGRAM ASTRONAUTS. Albert was elected speaker of the House in 1971, and at the resignation of Vice Pres. Spiro Agnew, and until the swearing in of Gerald Ford as his replacement, Albert was a "heartbeat away" and would have succeeded as president had Richard Nixon resigned or otherwise been unable to fill the duties of the office. (Courtesy of Library of Congress.)

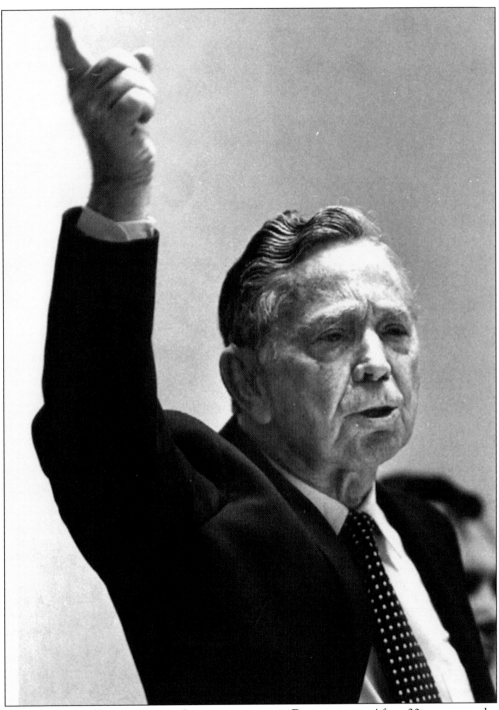

CONGRESSMAN CARL ALBERT SPEAKING AT HIS RETIREMENT. After 30 years as the representative for Oklahoma's Third Congressional District and six years as speaker of the House, Carl Bert Albert announced his plans to retire at the end of the 94th Congress in January 1977. Albert retired to McAlester, where a monument in his honor was later erected. (Courtesy of Lesley Brooks.)

BIBLIOGRAPHY

Benson, Henry C. *Life Among the Choctaw Indians, and Sketches of the South-west.* Cincinnati, OH: L. Swormstedt and A. Poe, 1860.

Bryce, J. Y. Early Schools in Choctaw Nation. *Chronicles of Oklahoma.* Guthrie, OK: 1926. p. 160.

Foreman, Grant. *The Five Civilized Tribes.* Norman, OK: University of Oklahoma Press, 1934.

Morris and McReynolds. *Historical Atlas of Oklahoma.* Norman, OK: University of Oklahoma Press, 1965.

Nesbitt, Paul. J. J .McAlester. *Chronicles of Oklahoma.* Guthrie, OK: Oklahoma Historical Society, 1933.

O'Brien, Greg. Mushulatubbee and Choctaw Removal. *Mississippi History Now.* Jackson, MS: Mississippi Historical Society, 2006.

Pittsburg County Genealogical and Historical Society, *Pittsburg County, Oklahoma: People and Places.* McAlester, OK: 1997.

Shuller, M. D., Thurman. An Address on the Occasion of the Eighth Annual Heritage Day. McAlester, OK: 1996.

Tagg, John P. *Geological History of Pittsburgh, Pennsylvania Coal.* Pittsburg, PA: University of Pittsburgh, 2006.

Wooldridge, Clyde. Coal Towns and Mining Camps, Part 1. *McAlester News-Capital.* McAlester, OK: October 6, 2006.

Wright, Muriel. Additional Notes on Perryville, Choctaw Nation. *Chronicles of Oklahoma.* Guthrie, OK: Oklahoma Historical Society, 1930

Wright, Muriel. Brief Outline of the Choctaw and the Chickasaw Nations in the Indian Territory 1820 to 1860. *Chronicles of Oklahoma.* Guthrie, OK: Oklahoma Historical Society, 1929.

DISCOVER THOUSANDS OF LOCAL HISTORY BOOKS FEATURING MILLIONS OF VINTAGE IMAGES

Arcadia Publishing, the leading local history publisher in the United States, is committed to making history accessible and meaningful through publishing books that celebrate and preserve the heritage of America's people and places.

Find more books like this at
www.arcadiapublishing.com

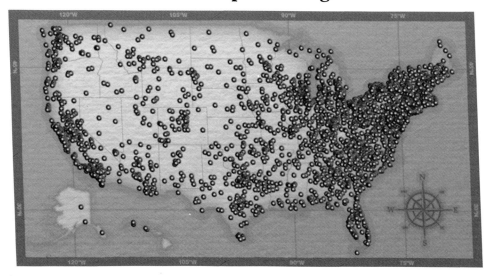

Search for your hometown history, your old stomping grounds, and even your favorite sports team.